# NEW JERSEY WINE

# NEW JERSEY WINE

## WINE

*A Remarkable History*

SAL WESTRICH

PHOTOS *by* JOHN MUTH

AMERICAN PALATE

Published by American Palate
A Division of The History Press
Charleston, SC 29403
www.historypress.net

Unless otherwise stated, all photography by John Muth.

Cover original oil painting by John Muth.

First published 2012

Manufactured in the United States

ISBN 978.1.60949.183.3

Library of Congress CIP data applied for.

*To the Memory of Nino Delduca*
*Neapolitan Poet and Dear Friend*

*Si vuje 'e vulite bbene, dicitincelle mò*
*pecchè, quanno so' muorte, che ce 'o dicite a fà?*
*Quanno se ne so' gghiute all' Aldila*
*nisciuno bbene 'e pò risuscita*

# Contents

*Preface*

A fine mist was falling as the ferry crossed the Gironde Estuary on its way to Royan. My friend and I were standing on the deck watching the Medoc shore recede when a gust of wind lifted the Michelin map we were studying, causing it to flutter down on the wet deck. Quickly retrieved, it was placed on a dry surface facedown and, as it turned out, right side up. Almost immediately, a faint but recognizable outline appeared. "Look!" my friend exclaimed. "The Delaware Bay!" I looked and had to agree; reversed and inverted, the Gironde Estuary bore an uncanny resemblance to the Delaware Bay, with the same gradual expansion to the ocean and a similar oblique orientation—except that the Delaware Bay takes a southeasterly direction, while the Gironde points to the northwest. Subsequent investigation revealed that the two waterways are similar in length, about eighty kilometers, while the width of the Delaware Bay is twice as large as that of the Gironde.

It was now my turn to call attention to a surprising detail: "And many of the New Jersey wineries are in the heart of the Medoc!" We both laughed as the same thought crossed our minds: might geological, meteorological and climatic similarities accompany the geographical ones, with all of the intriguing consequences this would have for winemaking in the Garden State? That evening, while sitting in a brasserie in Royan, we decided that the issue of parallels warranted further investigation and that it should be conducted within the context of a general history of New Jersey wine, which I, a historian, would write. (The bottle of Château Margaux that we were imbibing may have contributed to that decision.) I spent the next year and

a half exploring historical repositories, reading everything that had ever been written about New Jersey wines, visiting most of the wineries in New Jersey and persuading Pratt Institute, my employer, to grant me a sabbatical leave, which I used to write and rewrite the pages that follow. In one respect, I deviated from our original plan: rather than considering environmental parallels at the outset of the study, I shall do so at the end.

I wish to thank the following individuals for their invaluable help: Jason K. Tallon for his diligent research assistance, Shirley Kerby James for her expert typing and her insightful comments, Carol Leiman for her fine editorial work, Steve Riskin and Nick Sunday for help in preparing images and my son, John Westrich, for his many illuminating observations about wine and related subjects.

# PROLOGUE

# An Aperçu

H e was wrong, dead wrong. Like his other books and published works on history, he thought he was bringing his brand of micro-history to a book about New Jersey wines. As he often did, he would pick up the trail, still warm, of New Jersey wine history. From there, he would follow the thread and write a compelling and even tantalizing story. From the mid-1750s through the repeal of Prohibition, it was straightforward—a great story indeed. Then, to his surprise, he spotted a shadow figure moving through the landscape. A character appears related to wine only by his French birth, collecting and drinking French wines. This unlikely player is somehow there in the shadows of time spanning 1986 to the present.

His hair was dark and his suit was gray as he walked an unknown winemaker from a tiny New Jersey winery into the bowels of Margaux to meet the great Paul Pontallier. Two and a half decades later, his hair is gray and his suit is dark as he stands in the tasting room with Paul, as he has often done through the years, but now the subject is how George Taber, Margaux and this man played a major role in the history of the rise of New Jersey wines in the twenty-first century.

On second thought, maybe "he was wrong" is too strong; maybe astonished is better. Besides, like most people, he doesn't like being wrong. I must say now, looking back, it dawns on me that history was being made before his very eyes. Perhaps to go from a history professor, writing of the past, to something like a reporter, telling the story in real time, was just foreign to him. At any rate, it seems the collapse of the New Jersey wine

Unionville Vineyards. It's not the Stanley Cup.

industry during Prohibition, the burden new laws imposed until 1981 and the state's rise as a promising global wine region with several actors is a story that wrote itself. The historical process, like a gentle overlord, called the players to the stage and insisted, reluctant or not, that they were fated and must play their roles until the final triumph.

# The Journey Begins

## (1600–1800)

With its inviting harbors and navigable rivers, its fertile and varied soil, its temperate climate and abundant rainfall and its location midway between the northern and southern European settlements, New Jersey—or *Nova Caesarea*, as it was first named—had much to recommend it to seventeenth-century settlers. That the new land bore a resemblance to the one they had left behind was a further inducement to settle it. The Swedes were drawn to the banks of the Delaware River, which reminded them of the Klarälven; the English and Dutch preferred the familiar Atlantic and inland coastline, while the Scots chose the fertile land around the Raritan River, which brought back memories of the Galloway region. Diverse as their eventual destinations may have been, all were pioneers who realized that their well being—indeed, their very survival—would depend on their resourcefulness and unyielding resolve.

This is amply evident in the guidelines given in 1642 to Colonel Johannes Prinz upon his being named governor of New Sweden. He was to "arrange and urge forward agriculture and the improvement of the land, setting and urging the people thereto with zeal and energy, exerting himself above all other things that so much seed corn would be committed to the ground, that the people should derive from it their necessary food." One instruction attracts our attention: "And as everywhere in the forests, wild grape vines and grapes are to be found, and the climate seems to be favorable to the productions of wine, so shall the Governor also direct his thoughts to the timely introduction of this culture and what might herein be devised and perfected."

These were not the first Scandinavians to note the presence in the New World of grape-yielding vines, their Viking forebears seven centuries earlier having made the same discovery. In fact, they found that the grape vines were so abundant that they called the region—in all likelihood, the New England coastline—Vinland. Wild vines, it turns out, extended as far south as Florida, as is disclosed in accounts sent by the French, who landed on its coastline in the 1560s. They did not stay long enough to produce any wine, which was not the case with the English, who settled in Jamestown, Virginia, in 1609. Their leader, Captain John Smith, sent back the following report:

> *Of vines great abundance in many parts, that climbe the toppes of the highest trees in some places, but these beare but fewe grapes…Where they are not over shadowed from the sunne, they are covered with fruit, though never pruined nor matured. Of these hedge grapes were made neare 20 gallons of wine which were neare as good as your French British wine.*

Was Smith allowing his enthusiasm to cloud his judgment? This was clearly not the case with the Pilgrims of Plymouth Rock, who described the wine they drank during the first Thanksgiving celebration as "very sweete and strong," a common criticism of wine made from native American grapes. It did not take long for the settlers to realize that to produce wines of quality they would have to employ European grapes, the *Vitis vinifera*. These were first planted by the English in Virginia, then by the Dutch in New Netherland and eventually by the French in South Carolina but in each case without success. "Although they have several times attempted to plant grapes and have not immediately succeeded," wrote a seventeenth-century visitor to the Dutch colony, "they nevertheless have not abandoned hope of doing so. By and by, for there is always some encouragement, although they have not as of yet discovered the cause of their failure."

Hope was evidently not in short supply. When the two hundred acres of vines planted by William Penn in 1684 withered and died before the first crop could be harvested, the setback was accepted with equanimity—the effect, one can assume, of fervent religious faith. When such faith was lacking, the vagaries of nature could always be blamed. Learning that the European grapes he had planted at Monticello had died, Thomas Jefferson ascribed the cause to deficiencies in "the soil's fertility, the force of the wind, the presence [absence?] of a nearby forest or a running stream." His solution? "Find the right vine for a certain milieu and you can produce a

great wine." He eventually gave up on French varieties, turning to a hybrid grape, the Alexander, but without altering his view concerning the role of environmental determinants: "I think it will be well to put the culture of that grape without losing ones effort in the search of foreign grapes which will take centuries to adapt to our soil and climate."

Jefferson was a man of his time, the practical, problem-solving eighteenth century. There were no difficulties that diligent, inquisitive minds could not overcome. This was the reason why learned societies were founded: to incite the search for sensible solutions to practical problems. One such group was the American Philosophical Society, founded by Benjamin Franklin. Its British counterpart, the Society Instituted at London for the Encouragement of the Arts Manufacture and Commerce, commonly known as the Royal Society, is of particular interest because of the important role it played in furthering New Jersey viticulture during the colonial period. The society had, in 1758, offered a prize of £100 to the individual who would produce red or white wine "of acceptable quality." When no candidate presented himself, the society raised the prize to £200, with the stipulation that no fewer than five hundred vines would have to be planted and that the resulting wine would resemble "the sort of wine now consumed in Great Britain"—an allusion to wines produced with vinifera grapes.

Two prizes were eventually offered: one for the region north of the Delaware River and the other for the southern colonies and Bermuda—an indication of the importance attached by the Royal Society to American viticulture, and understandably so. Engaged in a protracted war with France, British wine importers were finding it increasingly difficult to obtain the fine wines of Anjou, Bordeaux and Côtes du Rhône demanded by the British upper classes. Moreover, if America could produce premier wines, Britain would then be able to curtail purchases of French wines, thereby reducing expenditures, the central aim of prevailing mercantilist policy. When again no candidate appeared, the deadline was extended to 1770.

Two New Jersey residents now came forward. One was Edward Antill, one of the colony's leading citizens who, in a lengthy letter to the Royal Society, declared that European vines were well suited to the soil and climate of New Jersey and that if few had thus far been planted, the reason was that "the people of America are generally unacquainted with the act of improving and cultivating of land to advantage; they jog on in the beaten path of their ancestors." He himself had been a target of scorn and ridicule for not following that path:

Edward Antill. *Courtesy of McCord Museum.*

*I have been thought by some gentlemen as well as the farmers very whimsical in attempting a vineyard; it is looked upon as an absurd undertaking, as a farce upon nature, as though I meant to extort from her what is not in her power to yield. As if America alone was to be denied those cheering comforts which nature with a bountiful hand stretched forth to the rest of the world.*

By 1765, Antill had planted eight hundred vines of such *Vitis vinifera* varieties as Madeira, Burgundy and Frontenac, as well as some native American vines "by way of trial," he explained. He placed his vineyard on a hill facing an important road "so that everyone may see what they otherwise would not believe practicable."

The other competitor for the prize was the New York–born William Alexander, then living in England, where he had gone to petition the House of Lords to acknowledge his claim to the lapsed earldom of Stirling. An active member of the Royal Society, could Alexander have decided to participate in the contest after learning that Antill had entered the list? As both were members of New Jersey's Provincial Council, could they have been social or political rivals? This would not have been surprising given

their social and class differences, Antill being a self-made man (he owned New Jersey's most important brewery), while Alexander descended from an illustrious Scottish family and was the proprietor of large tracts of land in New York and New Jersey.

Alexander returned to America in 1761 and soon thereafter began building a sumptuous country residence at Baskin Ridge, near Morristown, New Jersey, which was still incomplete fourteen years later. The enormous cost of construction—the house and grounds were designed in imitation of a large British estate, complete with a deer park—explains why Alexander remained financially hard-pressed throughout the remainder of his life, a circumstance that it appears did not adversely affect his lifestyle, which was that of a country gentleman of leisure. As a contemporary noted, Lord Sterling, the form of address favored by colonial society, "brought with him from England, horses, carriages, a coachman, valet, butler, cook, steward, hair dresser and a mistress." Baskin Ridge was a favorite destination of such distinguished visitors as George Washington, as the entries in his personal journal indicate: "May 24th [1775], breakfast at Princeton…and reached Lord Stirling at Baskin Ridge in the afternoon. May 25th, dined and lodged at Lord Stirling, drank tea at Mr. Kimbles [president of the New Jersey Provincial Council and a neighbor of Alexander]."

When the Revolution broke out, Alexander enthusiastically joined the Continental army—that the House of Lords had turned down his petition was not likely to dim his revolutionary ardor—taking command of the first New Jersey regiment. He participated in a number of battles, including those on Long Island, where he was taken prisoner but promptly exchanged for the governor of Florida, who had fallen into American hands, and at Middlebrook, New Jersey, following which he was promoted to major general. He died in 1781, in time to learn of the British surrender at Yorktown. Second only to Washington in military leadership, one can only speculate how high he would have risen had he not succumbed to illness in his fifty-fifth year.

By the time of his death, the vineyard at Baskin Ridge had long been abandoned. There had been difficulties from the beginning, as we learn from a letter written by Alexander to his friend the Earl of Shelburne in 1763:

> *The making of wine is worth the attention of Government. Without its aid, the cultivation of the vine will be very slow; for of all the vines in Europe we do not yet know which of them will suit this climate; and until this is ascertained by experiment, our people will not want vineyards; few*

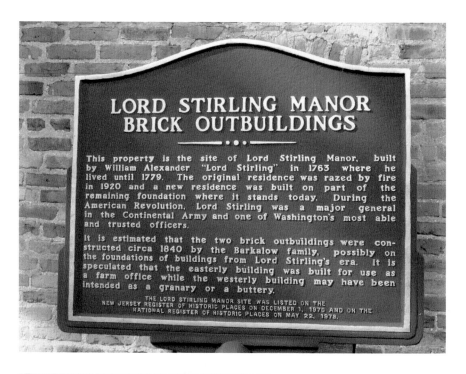

*Above*: Lord Sterling's estate, as a brass plaque explains.

*Left*: An ancient tree near Lord Sterling's estate.

*of us are able and a much less number willing to make the experiment. I have lately imported about twenty different sorts, and have planted two vineyards, one in this Province* [New York] *and one in New Jersey, but I find the experiment tedious, expensive and uncertain for after 8 to 10 years of cultivation I shall perhaps be obliged to reject nine tenths of them as unfit for the climate and then begin new vineyards from the remainder. But however tedious, I am determined to go through with it. Then I would wish to be assisted in it. I would then try it to a greater extent, and would sooner be able to join the cultivation of the grape into general use.*

Alexander did indeed "go through with it," and by 1767, as he informed the Royal Society, 2,100 vines had been planted.

When the Commission of Colonies and Trade, a committee of the Royal Society, met on October 28, 1767, it concluded that as both Antill and Alexander had satisfied the official requirements, the award of £200 would be given to each of them. The parent body, however, rejected this decision. A member subsequently revealed that Alexander had "failed in some essential point of certification," the nature of which was not disclosed. If, as has been suggested, the Royal Society's action was taken because Alexander continued to employ a title to which he did not have legal right, then how is one to explain the society's subsequent decision to award a gold medal "to the Right Honorable Earl of Stirling for having planted 2,100 vines in pursuance of the view of the Society"?

Ironically, had the society delayed its decision by two years, it would have given prizes to neither candidate. For by 1769, most of the vines that Antill and Alexander had planted had succumbed to disease. We ignore Alexander's reaction to the failure of his grape-growing endeavors, but that of Antill can be inferred from the following comment, which appears in the foreword of his essay on viticulture published in 1769: "I have, at last, after many hard struggles and many of painful hour, laboring under a tedious disorder finished the essay on the cultivation of the vine." Had Antill carefully examined the soil in which the vines had been planted, the "hard struggles," "painful hour" and "tedious disorder" could have been averted. For he would have discovered the presence of an aphid, subsequently named Phylloxera, and would have surmised that it had caused his vines to die. The insect is equipped with specially adapted mouthparts for piercing and sucking the sap from plants. That the American varieties he had planted "by way of trial" had survived would have led him to examine the two roots, whereupon he would have made a second important discovery: that the American ones

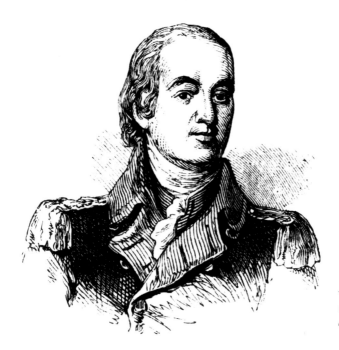

William Alexander.
*Courtesy of FCIT's clip art website.*

were thicker and tougher than the European roots and therefore able to resist the aphid's boring action. An obvious solution would then have suggested itself: grafting *Vitis vinifera* cuttings on American stock, thereby allowing the vines to grow in infested American soil. But the examinations did not take place, and as a consequence, a century had to elapse before Phylloxera came under control.

Antill's most enduring accomplishment was his study of grape growing and winemaking: "An Essay on the Cultivation of Vine and Making and Preserving of Wine, Suited to Different Climates in North America." It begins with an audacious claim: America could surpass Europe in winemaking "because we begin where they leave off, and we are free from the force of all their prejudices and erroneous customs." Fierce European resistance was therefore to be expected:

> *We must expect to meet with all the discouragement that the artifice of France, Spain, and Portugal can give us. We shall be told that our country is too new, that our soil is not fit, and our climate is reverse of that of wine countries. Besides that without the help of experienced vignerons it will be impossible for us to make any hand of it.*

All these arguments, Antill maintained, were without merit, especially that dealing with climate:

> *There are vines adapted to every country, to every region, from 50 degrees both North and South latitude down to Equator...* [However] *not every vine is fit for every country: some are earlier, some are later ripe; some are tender and delicate and will not stand adversity of winter, others are hardy and robust and will stand any weather.*

Ultimately, success will hinge on the astuteness of the grape grower. If vines are "carefully pruned, duly manured and properly cultivated they will generously reward you for your labor expense and care and will yield grapes above one hundred years as most writers affirm." Much of the advice offered is sound: the importance of keeping barrels clean; the desirability of placing flat stones near vines, "as they reflect great heat to the fruit and thereby contribute towards perfecting the vine"; and keeping the space between rows of vines free of other plants. Some advice, however, is of dubious value, such as when he warns of the harmful effect of placing hot dung near vines. And then there are recommendations that are patently erroneous, such as: "the greater [more abundant] the vintage, the better the wine." One cannot help but be amused when reading Antill's advice on how to deal with interlopers:

> *Grapes are delicious fruit and very tempting to people of every age and sex, the rude and unthinking sort will take advantage of your absence or neglect at the time of the fruit's beginning to ripe and rob and pilfer; such therefore must be carefully guarded against by a good high fence without, and a smart watchful guard dog within, and especially by the vignernon on appearing now and then with a gun in his hand walking about his vineyard. This will effectively prevent any attempts when they see what tends to be dangerous.*

A staunch defender of private property no less than a passionate grape grower, Anthill was not about to allow anyone to "rob and pilfer" his beloved grapes!

Antill died in 1770, six years before the world he knew was torn asunder by the American Revolution. He could therefore still be an ardent American Patriot and a loyal English subject. But with independence, a new America was born, one less inclined to follow foreign models. Washington's "Farewell Address" of 1795, in which he cautions the nation to be wary of "entangling alliances," is evidence of a turn inward away from Europe. Although a

political statement, Washington's pronouncement contains an implicit cultural message: America should distance itself from European traditions and ways and follow its own path. Viticulture was not exempt from the ethnocentric pull. That the Alexander and Catawaba grapes were American was undoubtedly a reason for their popularity. Even as ardent a Europhile as Thomas Jefferson could not resist the call of viticultural chauvinism, as is evident in the following pronouncement: "We can produce in the United States as many varieties of wines as Europe does; not the same ones, but undoubtedly of the same quality."

New Jersey winemaking in the years following Antill's and Alexander's heroic but futile efforts can only be described as calamitous. Locally produced wines were poor in quality and of no commercial value. A farmer might decide to plant some vines, but only so that he could produce a few barrels for his own consumption. This was the case with Jonathan Mellick, a German immigrant, who in 1751 built a farmhouse in what is today Bedminster Township in Somerset County. He installed a wine press described by a nineteenth-century descendant, Andrew Mellick, in *The Story of an Old Farm*:

> *The huge press standing against the west wall was built in Germany before 1735, and is a curiosity in its way. Though the wood is of walnut, it is black with age and its height is so great as to preclude the use of its round black ball legs…This massive piece of brass mounted furniture is capped by an overhanging cornice that projects some twenty inches and has stood in its present position since the house was built.*

That the first Mellick had incurred the not insignificant cost of having the press sent from Germany is an indication of the importance attached to winemaking in the colonial period. The poor quality of the grapes growing in New Jersey was in keeping with the backward character of agriculture in the state. Crop rotation, which European farmers had practiced since the Middle Ages, was unknown, resulting in harvests poor in quality and quantity. A common practice was for farmers to abandon land that had become barren in favor of greener pastures, usually out West. As Peter Kalm, a Swedish botanist who visited New Jersey in the middle of the eighteenth century, noted:

> *The corn field, the meadows, the forest, the cattle, etc., are handled with great carelessness by the inhabitants. Everyday their cattle are harassed*

*by labor and each generation decreases in goodness and size by being kept short of food. On my travels in the country I observed several plants that the horses and cows preferred to all others. But the inhabitants did not know how to turn this to their advantage, owing to little account made to natural history, that science being looked upon as a mere trifle and the pastime of fools.*

The situation had not greatly changed one hundred years later, as Andrew Mellick reveals:

*As for fruit no grapes were to be had excepting the poor native fox variety; and the improved kinds of peaches, pears, and melons had not been introduced. Of pears as well as apple there were plenty but no knowledge being had of nurseries, of grafting, they did not obtain anything approaching their present [1880s] perfection and deliciousness. So with the small berries as well and vegetables they were few in variety and few in quality. Potatoes, cabbage and Indian corn were plentiful but tomatoes, cauliflower, okra, lettuce, sweet corn, eggplant, and rhubarb were unknown.*

The absence of locally produced fine wines does not appear to have diminished the American appreciation of such wines, large quantities of which were being imported from France and Portugal, a trade that increased after American independence. Drunk on festive occasions by the rich and not so rich, bottles of claret, port and Madeira were readily available; they could be found gracing the best tables in New York, Boston and Philadelphia. Manasseh Cutler, in his journal of 1784, mentions a dinner he attended at Colonel Duer's town house in New York—Duer was William Alexander's son in law—in which fourteen different imported wines were served. The first five American presidents were enthusiastic and knowledgeable wine drinkers, Washington being particularly fond of Madeira, as was Thomas Jefferson, who consumed a bottle the night he wrote the Declaration of Independence.

What did the average American drink, if not wine? Cider and beer if he wanted to be moderately intoxicated, rum if he needed to go further. With its numerous apple orchards, New Jersey became the leading producer of cider in both the fermented and distilled versions, the later being the potent and ever-popular applejack. At the beginning of the eighteenth century, in townships along the Raritan River, there were at least eight distilleries in operation producing so much hard cider that prices declined to twenty-

five cents a gallon. From the beginning of their history, Americans have had an inordinate appreciation of alcohol, a reality recognized by George Washington, who, at Valley Forge, made sure that every soldier had his ration of rum. In *The Old Farm*, Mellick underscores the importance of inebriants in colonial and post-colonial daily life: "Did neighbors assemble to aid in raising a barn, to shear a sheep, or to draw and stack the ministers store of wood, the bottle was deemed requisite to give strength to arm and will and to restore flagging spirits." Alcohol was particularly appreciated during times of mourning:

> *Even when death entered the door, and friends and neighbors assembled to pay their final tribute of respect to the departed copious libations were considered necessary until it was not unknown for persons to reel in funeral processions or even to stagger on the brink of the grave. At the funeral of one particular beloved person in 1735 five pounds were spent on wine, beer and rum, spices, sugar, and pipes.*

The passion for alcohol grew in the nineteenth century, especially for the distilled variety. President Andrew Jackson—"Old Hickory," as he was affectionately called—was known to quaff down glassfuls of bourbon whiskey, his sobriquet becoming the name of a popular brand. And Ulysses S. Grant's love of the bottle is sufficiently well known not to require documentation. Alcohol-guzzling presidents of an alcohol-sodden nation! There is nothing surprising in the corresponding rise of the temperance movement.

However grim may have been the state of New Jersey viticulture in the early decades of the nineteenth century, there were glimmers of hope. For one thing, the character of vineyards was beginning to change for the better. For *Vitis labrusca* was being replaced by hybrids—accidental crossings between native and European grapes resulting in such varieties as the Alexander and Catawba. With higher levels of sugar, and therefore yielding more potent wines, such hybrids were a notable improvement over purely native grapes. Jefferson was much taken with the Alexander, declaring the wines it yields "as good as the best Burgundy and resembling it." The grape, which years before had been discovered growing in Governor Livingston's vineyard in Piscataway, New Jersey, eventually came to the attention of the Royal Society, which in 1768 began to offer prizes for its cultivation.

Although a viticultural backwater in the late eighteenth and early nineteenth centuries, New Jersey did not lack distinguished grape growers. One was Colonel George Morgan, a producer of clover, rye, alfalfa and

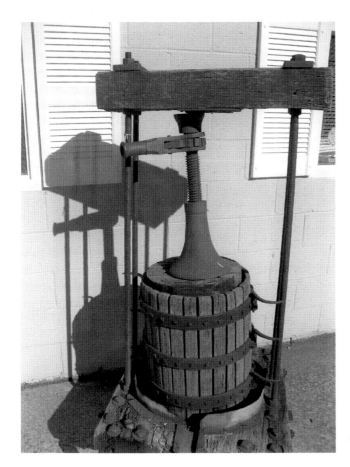

An ancient tool at Silver Decoy.

honey. The last had considerable appeal, as we learn from a letter written by Benjamin Franklin to John Morgan, the colonel's son:

> *I find myself greatly obliged to your father for the hive full of honey that he has so kindly sent me, and to you for thinking of me, and proposing it. I use it as part of my regimen every morning at breakfast. It is much the best I have met with in America and I think full equals the famous honey of Narbonne so much esteemed in France.*

Morgan left his farm in Princeton—it would eventually become part of Princeton University—and settled in Washington Township, Pennsylvania. He brought with him a large quantity of vegetable and grain seeds, peach pits and grape cuttings. The following entry appears in his journal: "An

account of the first experiment ever made west of the Allegheny Mountains by an individual to my knowledge, or information on the cultivation of the grape, except a few plants in gardens." He planted on his new property 3,480 cuttings of Bordeaux, Cape of Good Hope, Champagne and Burgundy obtained from Pierre Legaux, the noted viticulturalist. The journal contains a telling disclosure: "I owe this account to myself as an adventurous and expensive experiment, to my family for their honor, and to the public from principles of patriotism, believing that if successful I shall render more service to my country than by a thousand prayers for its peace and prosperity which I daily offer." A more patriotic declaration could not have been made.

Another New Jerseyite to leave the state for a new life out West was Nicolas Longworth, until the age of twenty a Newark resident. Settling in Delphi Township outside Cincinnati, he began planting Alexander grapes but, dissatisfied with their low sugar content, had them replaced with the sweeter Catawba. Beginning with four acres, his vineyard expanded until, in 1850, it was the largest in the United States, making Longworth one of America's wealthiest men. Other grape growers arrived, and soon the countryside around Delphi was covered with vines, the nearby Ohio River becoming known as the "Rhine of America." Wines from Ohio were being drunk throughout the eastern United States; Longworth's sparkling Catawba even found its way to Europe, the first champagne-style wine produced in the United States being particularly popular. Their vines decimated by Phylloxera, Europeans had to decide between drinking American wines or none at all and quite reasonably chose to do the former.

Both Morgan and Longworth achieved renown outside New Jersey. This was not the case with Paul Prevost, a Frenchman of Frenchtown, the creator—or discoverer—of the Delaware, for a time America's most popular grape. Sadly, little is known about this pioneering viticulturalist.

Vines require four to five years to become productive. Any revival in New Jersey grape growing would therefore be a slow, time-consuming process. And indeed, it was not until the 1840s and '50s that grape production began to increase. Significantly, it was not native American varieties that farmers were planting but hybrids—that is, accidental hybrids, not to be confused with the later French American hybrids—the Alexander and Catawba, soon joined by the Delaware. After a hiatus of decades, drinkable wines were again being produced in the state soon to be known as the Garden State.

# ℐ𝒉𝒆 𝓕𝓇𝑒𝓃𝒸𝒽 𝒜𝓇𝓇𝒾𝓋𝑒

## (SEVENTEENTH–NINETEENTH CENTURIES)

W hile one cannot speak of sustained French immigration to the American colonies, some notable examples can be cited. The Labadists were mystics who lived communally on their four-thousand-acre Maryland farm. There were the French settlers of Gallipolis in Ohio—victims of a fraudulent land scheme—who produced a wine so poor in quality that it was named *méchant Suresne* after a wine known for its sourness produced near Paris. The arrival of French Huguenots in South Carolina is of particular interest because, for the first time, a large group of settlers reached the New World with the intention of growing grapes. They had left France for England to escape religious persecution and in 1763 petitioned the British government to provide them with land in South Carolina so that they could "apply themselves to the cultivation of vines and of silk." The request was approved. Setting sail a year later, Huguenots reached South Carolina, founding the township of New Bordeaux in the southern part of the colony. They were joined four years later by another group of co-religionists led by the forceful Louis de Mesville de Saint Pierre.

But now came a setback: the colony's governing body refused to provide the settlers with the funds needed to purchase vine cuttings. Saint Pierre decided to return to England and appeal for financial aide to Lord Hillsborough, secretary for the American colonies, but to no avail. Rumors had it that Hillsborough had received a bribe of £250,000 from French wine merchants dismayed at the prospect of losing the lucrative American and British markets. Budgetary constraints are a more likely explanation. A costly

war with France had just come to an end, forcing the British government to reduce expenditures. It was about that time that Parliament, seeking new sources of revenue, passed the Stamp Tax and Revenue Act, which set the stage for the American Revolution. Samples of New Bordeaux wine were submitted to the Royal Society, earning for Saint Pierre a gold medal but nothing more. Other personal appeals proving to be equally fruitless—one was even addressed to King George III—Saint Pierre decided to take his message to the public publishing a tract bearing the title "The Great Utility in Establishing the Culture of Vines and the Absolute Necessity of Supporting the Infant Colony of French Protestants Settled in New Bordeaux South Carolina, Who have Brought the Culture of Vine and the Art of Raising Silk to Perfection." When nothing came of this, Saint Pierre had no recourse but to sail back to South Carolina—stopping off in Madeira, however, to purchase vine cuttings. (Had financial support been provided by wealthy Huguenots?) A final setback awaited his return, for the cuttings died soon after being planted. The New Bordeaux community eventually scattered, Saint Pierre being its last resident. He would die in the first year of the American Revolution, the victim of an Indian attack.

Although Saint Pierre failed to realize his vision, there is reason to believe that his efforts were not in vain. Winemakers from Bordeaux and elsewhere, particularly if they were of the Protestant faith, must have known of the fledgling community across the ocean that bore the crescent city's name. Thanks to Saint Pierre, sailing to the New World to grow grapes had become a realistic option for those unafraid to assume risks. New Jersey, so similar climatically to Medoc, would certainly have suggested itself as a desirable site to grow grapes. This may be one of the reasons why, after independence, New Jersey became the target of French political and economic designs. No sooner had the war between the American colonies and Great Britain come to an end than the government of Louis XVI decided to establish diplomatic relations with the various states. (Under the Articles of Confederation, each state had the right to enter into relations with foreign governments.) The envoy to New Jersey, New York and Connecticut was Michel Guillaume St. Jean de Crevecoeur, longtime American resident, acclaimed author (his "Letters from an American Farmer" was then the rage in London) and accomplished horticulturalist who introduced a number of European plants into America, including rhubarb and alfalfa. (Had Captain Morgan obtained his alfalfa from Crevecoeur?) He brought with him a letter dated November 26, 1783, addressed to "His Excellency Governor Livingston of the State of New Jersey," which read:

# The French Arrive

*The minister who is at the head of the nursery and botanical gardens in France has ordered me in His Majesty's names to acquaint Your Excellency that if the executive power of the Sate of New Jersey form an establishment of a botanical garden for the cultivation of useful and curious productions in America, His Majesty anxiously desirous in every way to give proof of his attachment to the United States of America has given directions to the said minister to send at His Majesty's expense from his royal gardens every species of seeds and plants that the Director the botanical gardens in New Jersey may wish to have.*

Livingston forwarded the missive to New Jersey's General Assembly, which did not hesitate to give its assent. The governor was asked to assure M. Crevecoeur that "whenever the State should establish a botanical garden, His Majesty's offer would be accepted." Why had New Jersey been chosen to become a French horticultural outpost? Crevecoeur himself may have been largely responsible, for he was a frequent visitor to New Jersey and, unlike Antill, had been favorably impressed with the skills and resourcefulness of its farmers, especially in regard to fruit growing. One cannot discount the possibility that strings were pulled by Benjamin Franklin, ambassador to France and a good friend of New Jersey, whose son and grandson owned farmland near New Burlington.

Two years later, André Michaux, a distinguished botanist associated with the Jardin des Plantes in Paris, arrived in New Jersey accompanied by his gardener, Paul Saulnier. He carried a flattering letter from the Marquis de Lafayette to George Washington and a commission from Louis XVI instructing him to establish a botanic garden. However, as he was not a citizen of New Jersey and therefore could not hold legal title to property in the state, Michaux was compelled to petition the assembly to have the restricting statute lifted, which it promptly did. The act that passed on March 3, 1786, reveals Michaux's impressive qualifications and the French government's great interest in the project:

*Monsieur André Michaux, botanist of His Most Christian Majesty, has represented that after having been employed for several years in the investigation of natural curiosities in Persia, and other parts of Asia, His Majesty has commissioned him, as his botanist, to travel through the United States of America and to establish an intercourse and correspondence between France and these States; that he has full powers to draw from*

Silver Decoy. Hints of the French countryside.

*France at the King's expense, any tree, plant, or vegetable, that may be wanting the country; and that he has like wise orders to send to France all the curiosities which may serve to extend a botanical garden of about 30 acres, to make useful experiments, in respect to agriculture and gardening, and intends to make a depository, not only of French and American plants, but of all the other productions of the world which may be drawn from the King's garden at Paris.*

Closer scientific ties between two states could not have been envisioned. A botanic garden did come into existence, placed in the care of Paul Saulnier, but it proved short lived. The turmoil that would lead to the French Revolution was beginning, and the royal authorities had more pressing concerns than exchanging plants.

The end of government sponsorship did not mark the end of French involvement in American agriculture, for French-speaking grape growers/winemakers—many from France but some from Belgium and Switzerland—began to make their way to America, often beginning their

trek in New Jersey. Among these, none played a more important and influential role than Pierre Legaux. Trained as a lawyer—which may explain his later predilection for litigation—Legaux reached America in 1783, settling in Spring Mills, a village north of Philadelphia. He lost no time purchasing four acres of land and began planting the three hundred cuttings—all *Vitis vinifera*—he had brought with him from France. He then set about organizing a joint stock company, the Pennsylvania Vine Company, capitalized at $20,000, whose investors included Aaron Burr and Alexander Hamilton. (Political rivalries could apparently be set aside when it came to growing grapes and making wine!) The vines, however, did not survive, and the company collapsed, leaving Legaux bankrupt. His plight can be gauged by the testimony of a visitor who found him "wearing stockings full of holes and a dirty night cap."

But far from giving up, he rented fifteen acres and was soon again planting vines, this time with success. Convinced that the thin oval leaves of the grapes were those of the Constancia, a *Vitis vinifera* from South Africa, a jubilant Legaux concluded that he had succeeded where others had failed. In fact, he was mistaken; the vine he had planted was the hybrid Alexander, a grape that yields a not disagreeable wine and certainly one vastly superior to that produced from native American grapes. His faith in American viticulture restored and in possession of sufficient funds thanks to the public stock offering that had resumed, Legaux purchased a large tract of land, which he named Montjoy, where he planted eighty thousand vines, making it possibly the largest vineyard in the world. News of this remarkable achievement reached Bordeaux, where it did not fail to provoke a hostile response from winemakers, who, as had their predecessors, feared the loss of the American market. (Such an eventuality had been recognized decades earlier when Abbe Raynal, after having visited America, warned of the danger American winemaking posed to the French economy.) An appeal was made to Bonaparte, France's first consul, who agreed that immediate action was required.

François André Michaux, the son of André Michaux and like his father a botanist, was dispatched to the United States to assess matters. We ignore the content of his report, but it must have been sufficiently alarming for the French minister in Philadelphia to be instructed to spare no efforts in getting Legaux to abandon his activities. As he had surrendered his citizenship and property holdings when he left France, he was to be assured that both would be restored and that he would be given a cash payment of $3,500 upon agreeing to uproot his vines and return to France. Legaux did not deign to respond. A natural disaster brought about what financial and other

inducements had not succeeded in accomplishing; hail fell, destroying most of the vines. But the pugnacious Frenchman simply purchased new vines, as we learn from an entry in his journal of April 15, 1805:

> *The day at half past ten o'clock at night I received a letter from Mr. McMahon* [secretary of the vine company] *with three boxes of grape vines, sended by Mr. Lee American Consul from Bordeaux, all in very good order and good plantes of Chateaux Margaux, Lafite, and Haut Brion, 4,500 plantes for $230.*

(English was evidently still a foreign tongue for M. Legaux.)

More disasters followed: a heat wave, an unending drought and an infestation of caterpillars. Then came the upheavals produced by the War of 1812, and this time Legaux capitulated. After a quarter century filled with both triumphs and disappointments, the Pennsylvania Vine Company ceased to exist. Legaux died in 1827, his state of mind poignantly captured by one of this last observations: "Nobody, no money and any assistance whatever to expect. What shall I do?"

Legaux's importance in the history of American viticulture cannot be overstated. Cuttings from his nursery found their way to vineyards throughout the United States, particularly those of New Jersey so close to Spring Mills. Colonel Morgan planted Legaux's cuttings on his farm in Princeton before taking them to western Pennsylvania. Here is where the French grape grower's influence began to wane. It wouldn't be until the 1980s that French winemaking techniques in New Jersey would insinuate themselves through an amazing twist of fate and circumstance.

# Transformations
## (1800-1860)

The years that followed the American Revolution were difficult ones for New Jersey and the republic. Having barely recovered from the Revolutionary upheaval, the United States found itself embroiled in another war—that of 1812—which was followed by an economic depression that lasted until the early 1830s. Agricultural prices sharply declined, with consequences particularly dire for large-scale winemakers (like Jacques Dufour of Kentucky, who went bankrupt). However, as the aim of most early nineteenth-century farmers was to achieve self-sufficiency rather than depend on market sales, declining agricultural prices had a negligible impact on a farmer's economic standing.

This began to change in the 1840s with the advent of railroads, highways and canals. The rural and urban worlds drew together, with benefits accruing to each. New Jersey strawberries, blueberries, peaches, apples and grapes were filling grocery bins in New York, Newark and Philadelphia. New Jersey peas were in such great demand that the Camden and Amboy Railroad became known as the Pea Line because of the huge amounts of peas it carried. Farmers began to prosper, the quality of their lives improving markedly. Clothing, for example, which had before been made by hand on the farm, was now mass-produced in factories and significantly cheaper. Numerous practical objects made their appearance: knives, saws, hammers, shovels and rakes, all manufactured on a massive scale by steam-driven machines operated, most likely, by one-time farmhands. Industrialization was accompanied by a rural exodus that had the effect of encouraging

further mechanization. With fewer farmhands, and these able to command premium wages, farmers were naturally inclined to employ laborsaving mechanical devices. One that came into use in the 1840s and '50s was the horse-drawn harvester. A significant improvement was the replacement of the handmade wooden plow, first by an iron plow introduced in New Jersey in 1797 and then by a factory-made steel plow. A change also occurred in the animal population, with the horse replacing the ox.

By the 1850s, New Jersey agriculture had become part of the cash economy. The bulk of fruit and vegetable production now went directly to wholesalers, who in turn sold to a network of retail grocery store. Food chains appeared; the Great Atlantic and Pacific Tea Company, known by its initials A&P, opened its doors in 1859. To increase profits, New Jersey farmers began to specialize, concentrating on a specific produce: dairy products, eggs and poultry, fruits and vegetable. (A photograph of Emilio Caracciolo shows him standing in front of a fruit and vegetable stand, whose contents certainly came from his garden.) Further specialization occurred in the 1860s when farmers began to grow single crops: corn, wheat, melons and grapes—the last intended for the table but also to meet the needs of the newly established wineries.

The great strides made by New Jersey agriculture after 1840 are all the more remarkable when the backwardness of the state's agriculture but a few decades earlier is recalled. We have already cited Antill's and Kalm's harsh judgments. The formation of scientific societies seemed the appropriate way to remedy the situation. A contemporary asked:

> *Why cannot the gentlemen of Philadelphia and its neighborhood who are lovers of agriculture form themselves into a society for the encouragement of that noble art? They might in monthly meetings be able to settle doubtful points to certainties; they might introduce a better system of rural economy and be in a few years of infinite service to their country.*

The proposal fell on receptive ears, for in 1781, an agricultural society—the New Jersey Society for Promoting Agriculture—was established. Other societies followed, at least six being formed between 1815 and 1830: the New Brunswick Agricultural Society in 1818, the Morris County Society in 1820, the Essex and Sussex County Societies in 1821, the Cumberland Society in 1823 and the Agricultural Society of Salem County in 1826. The results, however, did not accord with expectations. Decisions and pronouncements issued by "enlightened" gentlemen farmers were of little interest to the average

Art on the wall at Cream Ridge.

"dirt farmer." Prizes that did not take into account the actual cost of production meant little to a farmer struggling to survive. Elitist institutions imbued with a Jeffersonian faith in the power of reason, the societies had failed to meet the needs of the average farmer, who was seeking practical advice and not philosophical sermons. As a result, few survived the 1840s. The approaching demise of the New Brunswick Agricultural Society is foretold in the following observation made by one of its officers: "Of the benefits coming from agricultural societies there can be no doubt; yet, unless the societies be better supported, the advantages that may be expected from their continuance, must cease."

Agricultural societies could not, however, permanently disappear. The absence of technical schools and the scarcity of books made their existence essential if new ideas were to be discovered and promoted. They began to reappear in the 1850s but were significantly different form earlier ones, reflecting the changing character of farming. Waves of immigrants had arrived, altering the social and economic character of those who worked the land. The new farmer was not a wealthy gentlemen dabbling in farming—one thinks of the first five American presidents—but an ambitious, self-motivated and disciplined individual eager to adopt new ideas and techniques if these ensured abundance and well-being. The new societies sought to meet those aspirations and objectives. The Cumberland County Agricultural Society, founded in 1851, sponsored an annual fair with reaping and mowing matches, the vending of agricultural manuals, the presentation of new fertilizers and an inspection of individual farms by an official committee, the record kept by the secretary in a special book. The same practical bent is evident in the Somerset County Agricultural Society, established in 1853, which offered prizes for the best five acres of wheat, corn, oats and potatoes planted in the county. Some societies had a particular agricultural focus. Thus, the Egg Harbor Agricultural Society was founded in 1859, chiefly

for the improvement of viticulture. The Vineland Society was established in 1860 to promote the growing of fruits, vegetables and flowers. Societies could be blatantly commercial: the Fruit Growers Union of Atlantic County was nothing more than a marketing tool.

The proliferation of agricultural societies was not the only sign of transformative changes in New Jersey agriculture. One must also cite the large numbers of agricultural patents issued to New Jersey residents, the publication of numerous agricultural journals and the establishment of outstanding centers of scientific teaching and research (like Rutgers Science School, with a Department of Agriculture added in 1864, and the Stevens Institute of Technology, founded in 1870). While none of these developments had a direct bearing on New Jersey viticulture, they created a cultural atmosphere propitious to future innovations in that field. Resolving the problem of soil exhaustion is a case in point. A physician and farmer, Dr. John Reeve fell upon the novel idea of using lime to reduce the soil's acidity. The idea took hold. A Freehold newspaper in 1838 carried an advertisement for a limekiln operated by R. and W.M. Jacques of Keyport—the name indicating that French immigrants continued to settle in New Jersey. By 1850, it was the practice in Salem County to apply fifty to one hundred bushels of slaked lime to every acre of farmland.

If the use of lime did not gain immediate acceptance—other than in Salem, there is no sign of it being employed elsewhere until late in the nineteenth century—one reason was that a more plentiful and cheaper form of soil enrichment was readily available: stable manure produced by the large horse population of neighboring cities. The effect on orchard production was dramatic, a threefold increase occurring in the 1860s.

The emergence of a scientific/technological paradigm is evident in the rise of a new breed of thinkers: the technological savants, men such as George Eastman, Alexander Graham Bell, Samuel B. Morse, Cyrus McCommick and the towering Thomas Alva Edison of Menlo Park, New Jersey. John J. Mapes belongs in their company. Inventor, lecturer, editor, teacher and manufacturer, Mapes is the titan of nineteenth-century New Jersey agriculture, although now sadly forgotten. His portrait, which hangs in the Essex County Historical Society, projects intelligence and vision, levelheadedness but also nonconformity and a romantic sensibility. His life was a series of extraordinary accomplishments beginning with his unusual schooling, which ended with grammar school. Rising to the rank of professor of chemistry at the American Institute in New York, he was also an inventor and was elected, at the age of thirty-six, president of the Mechanic

Institute. Among his inventions and innovations was a centrifugal machine that separates sugar and molasses and techniques to improve dyeing, color making and steel tempering. Nearing the age of forty, he decided to leave the academic world so that he could devote all his time to "scientific farming," a term he coined.

In 1847, he purchased a thirty-acre farm on the outskirts of Newark, choosing it because of its dilapidated condition. As he explained, "We selected it for our proposed experiments, from the fact that all admitted the soil to be such as could not remunerate the farmer for its tillage. We made an analysis of the soil and forwit commenced its amendment, resorting to under draining, subsoil plowing and deeper surface plowing." Within three years, the farm was flourishing, with a comfortable profit margin. Mapes thought the moment ripe to reach out to the public. He announced that his farm would be open to visitors every Saturday so that "all new tools, including all of acknowledged merit…may be seen and tried by visitors." A committee of the American Institute of the City of New York visited the farm regularly and issued formal reports, taking special note of the numerous tools that Mapes had invented: a digging machine, root cleaner, ditching machine, horse hoe and a lifting subsoil plow. In one of the committee's reports we learn that Mapes planted 1,200 grape vines, five thousand pear trees and an undisclosed number of trees bearing apples, plums, peaches, apricots, cherries, small fruits—including ten varieties of gooseberries imported from Scotland—and every conceivable vegetable. Yields were impressive: 110 bushels of corn per acre, 1,000 bushels of carrots and 250 bushels of tomatoes.

Still a teacher at heart, Mapes announced his intention of enrolling students for "instructions in scientific farming." The following ad appeared in the *Working Farmer*: "Scientific Farming, Agricultural Advice. The subscribing editor of *The Working Farmer* will visit farms and advise proper modes of culture, necessary mixtures for general improvements of soils, manure for crops, make analyses of soils etc. He may also be consulted at his farm where practical instructions of his system may be seen." To promote his ideas, he visited various agricultural societies, giving talks on such practical matters as the importance of drainage, subsoil plowing and the use of manures, marl and other fertilizers. He was particularly well received in Monmouth County; he later recalled that he had never before faced an audience "who was apparently more anxious to avail themselves of the current improvements of the day." In 1850, he had the honor of speaking before the state legislature on the subject of scientific agriculture with the governor and leading New Jersey citizens present. He appears to have been

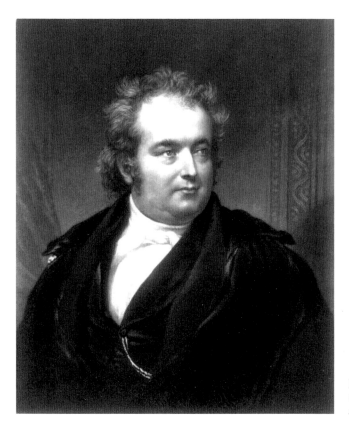

Michael J. Mapes.
*Courtesy of the National
Library of Medicine.*

a fine orator, as a local newspaper commented, "Few persons have the quick and vivid imagination, the easy liquid flow of language and the classical diction of Professor Mapes. The perfect mastery of his subject facilitated the natural rapidity of delivery."

Now calling himself a consulting agricultural chemist, Mapes turned his attention to the manufacture of artificial fertilizers. Having discovered a way to produce phosphates, he placed on the market, in 1852, what he proudly called the "improved and nitrogenized super phosphate of lime, manufactured by the Mapes Fertilized Works." It was the first such chemical plant in the United States and was directed after Mapes's death by his son Charles V. Mapes. There was litigation: his claim to have discovered the process of extracting phosphate from lime was challenged. The issue was settled in 1859, when the U.S. Patent Office ruled in Mapes's favor.

Still another of Mapes's achievements was the launching in 1849 of the *Working Farmer*, a monthly magazine "devoted to agriculture, horticulture,

floriculture, kitchen gardening, management of hothouses, greenhouses, etc, embracing the rights of agriculturists and the importance of the establishment of a Home Department of Agriculture at Washington." Printed in New York City, it was written and edited in New Jersey, in Mapes's old farmhouse, which served as his office and workshop. What distinguished the *Working Farmer* from other agricultural journals was its rigorous scientific approach to agricultural issues. This is evident in the very first issue, which contains an essay by Mapes on the scientific principles of plant growth. His aim, he explained, was to recognize "what influences are brought to bear by nature's laws to produce their enlargement from the seed, and what methods farmers can adopt to avail themselves of those laws." The magazine's staff was made up of former students who wrote on every aspect of agriculture. Forthcoming fairs and meetings of agricultural societies were duly listed, and a column was devoted to letters from individual farmers with the editor's reply. Important scientific works such as Liebig's *Principles of Agricultural Chemistry* were published in serial form. With a circulation of about ten thousand, the journal was one of the most popular in the United States. In 1861, it merged with the *United States Journal* to become the most widely read agricultural journal in the nation. It ceased publication in 1865, a casualty of the Civil War. Interestingly, it contained an article by Mapes on mulching of grape vines.

A final achievement of Mapes was the pivotal role he played in the creation of the Federal Department of Agriculture. In its editorial columns, the *Working Farmer* repeatedly urged the creation of such a department. "Thousands of dollars have been spent for improvements in telescopes but not one dollar for the improvement of the plow," wrote an indignant Mapes. His efforts were crowned with success, for in 1862 the Federal Department of Agriculture came into existence.

Through his writings, inventions, lectures and farming activities, Mapes unalterably transformed New Jersey agriculture. Traditional ways inspired by folk tales and almanacs were abandoned in favor of scientific manuals and the precise findings of laboratories. In the United States and in Europe, a second scientific revolution was taking place, this one in the living sciences. A number of nature's mysteries, some with significant implications for viticulture, were now solved: the nature of fermentation (Pasteur), the impact of soil chemistry (Liebig), the determining role of genetics (Mendel and De Vries), and, the crowning achievement, natural selection as the mechanism of evolutionary change (Darwin). Theory had caught up with practice, the investigator of nature's laws joining the technological savant in launching the brave new world of scientific progress.

Although New Jersey farmers in the 1850s were significantly better off than those of 1800, troublesome concerns had not been dispelled. Incomes of farmers continued to lag far behind those of the urban middle class. Credit was hard to secure. And the Civil War was looming on the horizon. Prescient observers such as Nathaniel Hawthorne, Herman Melville and Emily Dickinson sensed that something precious had been lost—a pastoral idyll? The sense of independence that accompanies self-sufficiency? The secure feeling of knowing that one is protected by the vagaries of the marketplace (a feeling that did not survive the crash of 1873 and the long depression that followed)? Retaining idealistic aspirations but also accepting the challenges posed by the scientific and industrial revolutions, mid-nineteenth-century New Jersey agriculture was a mix of vision and hard-headed realism, a willingness to hold on to traditions, but not if that entailed sacrificing the fruits of progress. The arrival of waves of immigrants added another complexity, one that proved to have far-reaching consequences for winemaking.

If in our survey of mid-nineteenth-century agriculture we have ignored developments in viticulture, it is because, until the 1850s, such developments were inseparable from those taking place elsewhere in agriculture. Grapes were simply another produce, wine another beverage. This began to change in the 1860s. For the first time, winemakers began to give serious thought to the type of grapes they were growing. Of one thing everyone was certain: European varieties would not grow in American soil. And as wine produced with native American grapes was barely drinkable, the solution clearly pointed in the direction of hybrids, which before 1850 meant accidental hybrids such as the Alexander and Catawba. (S. Johnson has the distinction of being the first to plant the Alexander in New Jersey. Interestingly, his work, *Rural Economy*, contains forty-two pages devoted to hybrids.) While a marked improvement over *Vitis labrusca*, accidental hybrids yield wines that contain three to five fewer degrees of alcohol per volume than those produced from *Vitis vinifera* grapes, and they leave a disagreeable aftertaste—what has been described as "foxiness." Better-quality grapes would therefore be required; that is, hybrids deliberately produced, a not impossible feat given the strides made in hybridization. The first to have practiced the systematic breeding of plants—although apparently not of grapes—were Joseph Cooper and his father, from Gloucester County, New Jersey. In a report sent to the Philadelphia Society for Promoting Agriculture in 1799, Cooper described how he and his father had produced new varieties of peas, lettuce, squashes, asparagus, potatoes, radishes, corn, watermelon and apples. (A popular

apple known in France as *la délicieuse* and in the English-speaking world as Lady Lucy was bred by the Coopers.)

Controlled hybridization of grapes had to await the 1850s, although signs that viticulture was moving in that direction go back to the beginning of the century. A landmark was the publication in 1806 by Bernard McMahon, an accomplished horticulturalist from Philadelphia and an associate of Pierre Legaux, of the *American Gardener's Calendar*, in which he distinguished four native American species: *Vitis sylvestris, labrusca, taurina* and *serotina*. McMahon understood perfectly how hybrids are produced: "There are several varieties produced by the intermixture of the above, with one another, or with the varieties of the *vitis vinifera* which are called hybrids or mules; the most noted is the Alexander or Tasker's grape." While his intention was to explain the process of hybridization, the possibility of deliberately producing hybrids was not lost on the reader. McMahon has an even greater claim to viticultural renown: "I would suggest the idea of grafting some of European kinds on our most vigorous vines, which, no doubt, would answer a very good purpose." He was raising the tantalizing possibility of mounting *Vitis vinifera* vines on American roots, which would allow them to grow in Phylloxera-infested soil—an idea that did not take hold for another century.

In 1852, at a meeting of the American Horticultural Society, Dr William Valk of Flushing, New York, exhibited grapes he had grown from seeds produced by crossing Black Hamburg (a *Vitis vinifera*) with Isabella (a *Vitis labrusca*). A.J. Downing, a noted horticulturalist, corroborated the accomplishment: "There can be no doubt that this is the first genuine cross between the foreign grapes and our natives." He named it the Adda. Another hybrid came on its heel: Alan's Hybrid, a cross between Golden Chasselas (*Vinifera*) and Isabella, the work of John Fisk Adam of Salem, Massachusetts. A veritable avalanche of hybrids followed: by the end of the nineteenth century, there were more than one thousand in existence. Other fruits, one must note, were undergoing the same proliferation. In 1847, Henry Winthrop Sergeant of Fishkill, New York, cultivated 106 varieties of pears, 60 of peaches, 56 of plums, 14 of nectarines, 12 of apricots, 20 of cherries, 3 of quinces, 6 of raspberries, 4 of currants, 14 of strawberries and 12 of gooseberries. The idea of altering the course of evolution must have been greatly appealing to naturalists, especially after the publication of Darwin's *Origin of Species* in 1859.

A New York farm cultivating nectarines? Yes, by planting them in greenhouses as Sergeant was doing. The idea caught on, and before long, nearly every farm in the Northeast had a greenhouse where exotic and out-

The road to Villa Milagro.

of-season fruits were being grown: figs, dates, pomegranates, pineapples and grape. These commanded premium prices: three dollars for a pineapple or a bunch of grapes—for many a week's wages! By the 1870s, most greenhouses had disappeared. What was the point of erecting them when grapes and other fruits could reach eastern markets days after being picked. But could not the same argument be made for eastern grapes being grown outdoors? This was precisely what began to happen; winemakers in New Jersey shipped in grapes that had been grown in California. From that, it was a short step to bottling wines that had been vinified in California.

Mid-nineteenth-century New Jersey farmers continued to make wine as their predecessors had done a century earlier, the typical farm having a small vineyard and a winepress. As already indicated, whatever wine was produced was intended for the farmer's own table, which was not the case in Ohio, Kentucky, Indiana, South Carolina, New York State and, the rising giant, California, where wineries were marketing their wines. The situation in New Jersey began to change in the 1850s and '60s, when a handful of wineries were established. A number of reasons can be advanced to explain New

Jersey's viti-vinicultural backwardness. The state's farmers were disinclined to employ the newly bred hybrids, preferring to continue using existing varieties such as Catawba and Delaware. Then there was the pernicious practice of abandoning land when it became depleted or ravaged by insects and fungi. As an observer noted: "When, after continued cropping, a field becomes exhausted, it is customary to abandon it, move to a new area, which in turn was farmed until its plant food was depleted." The problem was particularly acute in the state's southern counties, where large areas became completely barren. One must therefore be wary of relying on Ive's lithographs when forming an opinion of mid-nineteenth-century New Jersey farm life! The situation had, however, a silver lining: as land values declined, land became affordable to financially hard-pressed, recently arrived German immigrants, many of whom were experts at grape growing and winemaking.

Still another reason can be offered to explain New Jersey's neglect of viticulture: the availability of a far less costly fruit, the apple, which can yield higher levels of alcohol. Cider, it must be noted, contains 12 to 16 percent of alcohol per volume—almost twice that of farm-made wine. Newark was soon known as the cider capital of the world, with 307,000 gallons produced annually. Boasting 388 distilleries in the 1830s, New Jersey was the largest producer of cider in the United States.

# Setbacks and Golden Moments

## (1860–1920)

The 1860s were difficult years for New Jersey grape growers and indeed for all farmers. As if the consequences of the Civil War were not enough, the state also had to contend with natural disasters, principally a calamitous insect attack. Dr I.P. Trimble, entomologist for the New Jersey Agricultural Society, in a report issued in 1866's *Insect Enemies of Fruit and Fruit Trees*, painted a grim picture of New Jersey horticulture: "Ravages made by certain insects on fruits, fruit trees and grains within the state have occasioned great loss to fruit and grain growers, and have served to discourage the planting of fruit trees as a business connected with the agricultural industry of the state." The magnitude of the threat can be gauged from the 40 percent decline in the value of orchard products. The following forlorn assessment appeared in the Agricultural Society's report of 1872: "We remember, in our school days, how our geography books were wont to describe the state of New Jersey as 'famous for its fine fruits.' The more truthful description nowadays would be 'famous for its wont of fruit'…We ask ourselves where is all this to end? Are we to abandon entirely the culture of food in New Jersey?" Written for a state agency, the report had to end on an optimistic note: "Our entomologist bids us to take courage. He shows us that there are means of baffling this enemy. He assures us that the protection of food from these insects can be made a fixed science, so that the man who goes into the business of fruit growing may be sure of success." Details of the "fixed science" are not given, and with good reason, for the problem of insect infestation was not resolved then and would not be for decades to come.

It was during this troubled period that the first commercial wineries were established in New Jersey: the Dewey Winery in 1857, the Renault Winery in 1864 and the Kluxen Winery in 1865. The first would disappear in the 1950s, and Kluxen in the 1970s, leaving only Renault still functioning today, making it the oldest winery east of the Rockies. It was founded by Louis Nicolas Renault, the son and grandson of French barrel makers in the Champagne region who settled in the United States in 1855. For a time, Renault was a salesman for imported French champagnes and then decided to produce his own wines. Visiting Atlantic County in southern New Jersey, he was impressed by its climate and sandy soil, which reminded him of the Bordeaux region, and he proceeded to establish his vineyard and winery in Egg Harbor, a rural town some twenty miles from the Atlantic Ocean. Success was almost immediate. Renault became an important producer of "champagne." Notice the quotation marks, for the term cannot be used officially to describe wines produced outside Champagne, France. By the end of the twentieth century, Renault was the largest producer of sparkling wines in the United States. Egg Harbor proudly called itself "Wine City."

The sudden surge of winemaking in New Jersey coincided with the arrival of a new grape: the Concord, a *Vitis labrusca* discovered by Ephraim W. Boll of Concord, Massachusetts, hence the grape's name. Grown from a chance seedling and therefore in all likelihood a hybrid, Concord vines bore their first important harvest in 1849. Exhibited in 1853 at the Massachusetts Agricultural Society, the new variety achieved instant popularity. The New York–based Prinz nursery, which was promoting the grape, could not contain its enthusiasm: "This remarkably fine new American variety is sufficiently hardy to withstand the coldest climate…A most vigorous growing vine…The berries have never been known to mildew, rot, and drop off, under any circumstances during the five years since it has borne fruit." The campaign was widely successful. More Concord vines were planted in New Jersey, New York and Pennsylvania during the second half of the nineteenth century than all other varieties combined. Neither Concord wine's aggressive foxiness nor its disagreeable cloying sweetness—the result of adding large quantities of sugar during fermentation—dimmed its appeal. In fact, the very opposite occurred; the flavor and aroma of Concord became the standard by which other wines were judged. A ploy was devised to dissimulate any unpleasantness: add carbonation, and *voila!* A sparkling wine! Unprincipled winemakers were learning the tantalizing possibilities of adulteration.

A further sign of vitality was the founding in 1855 of the Egg Harbor City Agricultural Society, which sought to encourage farmers to grow grapes. A

year earlier, tests had shown that the soil and climate of Egg Harbor were suited for such grape growing. (Had Louis Renault been persuaded by these findings to establish his winery there?) About forty varieties were considered, of which a dozen—including Concord, Catawba, Ives and Norton—were deemed particularly suitable for the region. A propitious development was the arrival of large numbers of German immigrants whose commitment to winemaking was soon apparent. In 1862, an Atlantic County newspaper reported that Germans who had settled near Egg Harbor were realizing profits of $800 an acre from their vineyards—a considerable sum at that time. The *Gardener's Monthly* reported in 1865 that Egg Harbor was full of Germans making wine "as good as any in the world." Some of the names have survived: Julius Hincke, Jacob Shuster and son, August Heile, Charles Saumann and J. Furrer. Hincke seems to have been particularly eager to achieve renown, his wines being exhibited in the Philadelphia Centennial Exhibition in 1876, as well as at the Paris Exposition of 1878, winning medals in both. By the middle of the 1870s, an impressive seven hundred acres of vines had been planted around Egg Harbor, yielding 150,000 gallons of wine. A visitor observed that Atlantic and Cape May Counties were "dotted with vineyards and every farmer had his wine cellar."

Southern New Jersey in 1877 was well on its way to becoming a premier grape-growing/winemaking region. Then, disaster again struck; this time, it was black rot, a fungus that attacks foliage. An antidote was sought in a mixture of sulfur and lime, but it proved ineffective. By the early 1880s, the disease had spread to Cape May, decimating its vineyards. Vines everywhere were being uprooted, and the land was diverted to other crops or simply abandoned. Land values plummeted. The future of winemaking in New Jersey had suddenly become very bleak indeed.

The destruction of New Jersey's vineyards coincided with a long-standing downturn in the American economy. These were hard times, with high unemployment and declining prices and incomes—a familiar scenario. As often happens when times are difficult, a scapegoat had to be found to bear the blame. "Demon rum," a term broad enough to include the higher and lesser inebriants—rum, whiskey and applejack as well as beer, cider and wine—came under attack from what came to be known as the temperance movement. In an embryonic state in the early years of the nineteenth century, the movement assumed a mass character and militancy in the closing decades, and nowhere more so than in New Jersey, a state with a strong evangelical tradition and therefore prone to anti-alcohol sentiment. The imbibing of alcohol, condemned earlier as a social scourge, was now

held up as a diabolical ploy to ensure eternal damnation. For members of the temperance movement, the only solution that could be envisioned was prohibition, outlawing the production and sale of all alcoholic beverages.

A more divisive issue could not have been imagined. New Jersey found itself divided along religious and social lines, the "drys" consisting of conservative Protestants and long-term residents of the state and the "wets" comprising recently arrived Catholic immigrants from Ireland, Germany and, later, Italy. The drys had the support of two formidable organizations: the Woman's Christian Temperance Union, founded in 1874, and the Anti Saloon League, organized in 1894. A Prohibition Political Party was formed; its candidate, Clinton Fish, received nineteen thousand votes in New Jersey's gubernatorial election of 1886, about 8 percent of the votes cast. Although still a miniscule movement, winemakers were paying heed. As early as 1867, the Dewey Winery advertised its Black Rose, not as an agreeable wine, but as "well suited for medical use," presumably to assuage the moral sensibilities of those who might be inclined to take an occasional nip. Entire communities began to go dry. A city that achieved certain notoriety was Vineland, founded in 1861, with the stated aim of transforming the town and region into a "vine country," above all not a "wine country," the city charter prohibiting the production and sale of all alcoholic beverages. Vineland has the distinction of being the first "dry" city in New Jersey and possibly the United States.

Vineland has the additional distinction of being the birthplace of grape juice, considered for a time a rival to wine. It was the brainchild of a dentist, Dr. Thomas Welch, originally from upstate New York, who had moved to Vineland seven years after its founding, drawn by the town's ban on alcohol. A fervent supporter of the temperance movement, Dr. Welch viewed wine as an infernal concoction deserving total interdiction. His religious zeal must have been exemplary, for he was named deacon of Vineland's Methodist Church and as such was entitled to deliver Sunday sermons. In one of these sermons, Dr. Welch formulated theological argument in support of prohibition. The Scriptures, Welch argued, without citing verse, distinguished between fermented and unfermented wine. When Jesus made of wine a symbol of his blood, he meant unfermented wine, for the Son of God could not have associated Himself with a substance so vile and corrupting as alcoholic wine. Communion, therefore, had to be celebrated with a nonalcoholic wine. But how was such to be obtained?

Welch could not answer that question. By chance—or was it the work of God?—he came upon an article published in 1867 by the California State Agricultural Society that described how one Louis Pasteur had discovered

that by heating grape juice to 140 degrees Fahrenheit, whatever yeast it contained was destroyed, thereby preventing fermentation. An elated Welch decided to repeat Pasteur's experiment. With the aid of his seventeen-year-old son, Charles, he crushed enough grapes to fill a dozen quart bottles, made sure they were sealed with cork and wax and had them placed in boiling water. The result confirmed Pasteur's finding. Welch named it unfermented wine, unaware that he was coining what has come to be known as an oxymoron.

Years passed. The concoction would have been forgotten had not Charles, now also a dentist, decided to make a last effort at commercial success. He first had to find a brand name and decided on the authoritative and reassuring "Doctor Welch's Grape Juice." Then he set out to promote the beverage, publishing a number of magazines that touted its therapeutic properties. One advertisement read: "Dr. Welch's grape juice is especially recommended in the case of typhoid fever, pneumonia, pleuritis, rheumatism, for lying in patients and for all forms of chronic disease except diabetes mellitus"—the last disclaimer intended no doubt to buttress scientific pretensions. Whatever its medical properties, the religious association was not allowed to be forgotten: "If your druggist hasn't the kind that was used in Galilee containing not one particle of alcohol, write us for prices." Charles Welch soon abandoned dentistry so that he could devote all his attention to his enterprise, now incorporated as the Welch Grape Juice Company.

It was 1893, the year of the great Columbia Exposition held in Chicago to celebrate the 400th anniversary of America's discovery. Deciding that this was an opportunity not to be missed, Welch attended the exposition, setting up a booth and personally handing out grape juice samples to passersby. It signaled a significant change in marketing strategy: discarding any religious or medical allusions in favor of purely sensory ones—the simple pleasure of drinking a pleasant beverage. Doctor Welch's Grape Juice was shortened to Welch's Grape Juice, as it is known today. Was Welch aware of the creation a year earlier of a carbonated beverage called Coca-Cola, soon joined by Canadian Dry Ginger Ale—the second word making clear for whom it was intended? Americans could at last quench their thirst without resorting to an alcoholic beverage. It would not be hyperbolic to speak of a revolution in drinking habits—the increasing popularity of "soft" drinks. The success of Welch's Grape Juice was truly remarkable, with fifty thousand gallons sold in 1897 and one million a decade later. By then, the company was no longer located in New Jersey, ravaged by black rot, but in upstate New York, which apparently had been spared the disease.

Dr. Thomas Welch died in 1903, just as his creation was succeeding beyond his wildest dream. A formal photographic portrait taken just before his death reveals much about this remarkable man. He is sitting in an armchair with his son and grandson standing at his side and his great-grandson sitting on his lap. The flowing white beard, erect posture and still-massive hands suggest an all-powerful patriarch, possibly an Old Testament prophet. The countenance is particularly revealing: the determined, uncompromising shape of the mouth; the penetrating, far-seeing gaze in which the faint traces of a smile can be detected; the self-satisfied—or is it self-righteous?—look. We are in the presence of an inner-directed God-fearing man who has labored diligently in the vineyard—to carry out the religious allusion—and now serenely awaits his just reward. Thomas Welch is content, and with good reason, for he has realized the nineteenth-century ideal of achieving worldly success while accomplishing the Lord's work. And then there is the comforting gesture of Charles's hand touching his shoulder reassuringly, a message from son to father that his life's work will endure. Could Dr. Welch have indeed been a prophet, the smile provoked by the certain knowledge of a forthcoming event: Prohibition?

The difficulties confronting New Jersey grape growers continued until the 1890s. There were natural disasters (black rot being the most serious) and disasters of an economic character: the collapse of agricultural prices. Making the situation for New Jersey particularly dire was the completion of the Transcontinental Railroad in 1869, which, as we have seen, allowed California grapes to reach eastern markets in three days. (A method of preservation was to pack them in sawdust.) If New Jersey viticulture managed to survive, it was largely because of another wave of immigrants, this one from Italy, which brought with it the knowledge and techniques gleaned from millennia of grape growing and winemaking and that enthusiasm for hard work characteristic of those who reach our shore. The first reference to Italian grape growing appears in a 1885 report of the State Board of Agriculture: "An Italian vine dresser in Vineland imported last year 100 cuttings of White Malaga grapes and has planted them thus in New Jersey sand [sand?]. It is the general opinion among our Italian settlers that vines should be deeply rooted," to say the least. The Italians' arrival was welcomed news, as the New Jersey Board of Agriculture indicated in its 1909 report: "The coming of the Italian to our southern countries means a steady increase in the production of grapes and small fruits." Responsible for the very survival of vini-viticulture in New Jersey, the names of these hardworking and remarkably brave immigrants merit remembrance, but the traces are sometimes faint. We can cite the

following: Plagido Tomasello, who immigrated in the late 1800s and settled in Hammonton; Eugenio Ventimiglia, who arrived in America at the turn of the century in Sussex County; Giovanni D'Agostino, who in 1913 purchased the Renault Company, then the largest winery in the eastern United States; and Angelo Quarella, who arrived in 1918–19 and whose grandson would someday found Bellview Winery in Landisville. There's also Matty Matarazzo's grandfather, who arrived in 1921 and established a farm that eventually became the Four Sisters Winery in Warren County; Emilio Caracciolo, a dedicated winemaker who left behind a legacy that survives in Amalthea Cellars; the Neri family, who founded the Hopewell Valley Wineyards in Mercer County; the Giunco family, grape growers and winemakers of Monmouth County; and the Marchesi family, founders of Alba Vineyards. Others who became involved in winemaking include the Gaventa, Amabile, Dimateo, Natali, Dibella, Gambino and Valenzano familes.

A noteworthy development in the history of New Jersey agriculture in the waning decades of the nineteenth century was the emergence of highly specialized biological disciplines. What John Mapes had done working alone and often in an idiosyncratic fashion now became a collective effort, with research systematically and rigorously conducted in highly specialized laboratories. In 1880, the Rutgers Experimental Station was established

> *for the purpose of promoting agriculture by scientific investigation and experiment: to analyze and test fertilizers, cattle food, seeds, soils, waters, milk and other agricultural materials and products, to identify grasses, weeds and useful or injurious insects, to give information on the various subjects of agricultural science, for the use and advantage of the citizens of New Jersey.*

The station became a leading researcher in insect control. An 1890 report identified the squash and melon borer, the cabbage maggot, plant lice (a reference to Phylloxera?) and the rose chafer, an insect that feeds on grape leaves. Extensive studies of the last made in the vineyards of Colonel A.W. Pierson, of Vineland, showed that hot water would destroy the insect, but it was dismissed as impractical. The task of finding more effective insecticides was assigned to two new departments at the station: Chemistry and Botany. The last was headed by Dr. B.D. Halsted, who was far from optimistic when assessing the future of horticulture in the state and elsewhere. "The weeds," he wrote in his first report, "we shall always have with us. Every farmer, orchardist, and gardener is living under a curse that has long ago found

Ventimiglia, exterior view.

expression in the following terms: by the sweat of thy face shall thou eat bread." His message becomes apocalyptic: "The land as well as the person who tills it is cursed with an inherent tendency to produce evil instead of good." The rest of his report is, thankfully, factual. It lists 265 species of weeds divided into annuals, biannuals and perennials. Illustrations of the more common weeds are provided, with suggested methods of control. One of America's preeminent botanists, Halsted was asked in 1893 to prepare an exhibit of American weeds for the Universal Exposition of that year—the same in which Dr Welch put up a stand. Two hundred species were mounted on standard-sized sheets with printed labels. A case was added containing 100 kinds of weed seeds. We ignore how these were received at the exposition.

Halsted's other notable achievements include his study of New Jersey's poisonous plants, a work acknowledged as definitive one hundred years later; his collection of over eleven thousand specimens of fungi, which has been of considerable aid in the study of obscure plant diseases; and his collection of seven thousand vascular plants growing in the state. In 1919,

thanks to his pioneering work, the Department of Botany was transformed into four new departments: Horticulture, Plant Pathology, Seed Analysis and Plant Physiology. These were preceded by the establishment of an Entomology Department, possibly the first in the United States, which had already been established and placed under the direction of Dr. John B. Smith, a specialist in such insects as the horned fly, elm leaf beetle, imported elm borer, clover leaf beetle, asparagus beetle, grape Phymatados, yellow-necked apple tree caterpillar, plum curculio, fall Webb worm and periodical cicada.

Despite impressive results, the battle with insects and fungi was far from won. In fact, as the new century began, things took a turn for the worse, as the 1909 report of the State Board of Agriculture confirms: "The farmer has found in recent years a numerous host of injurious insects, of blights and fungus diseases assailing his crops, and even his stock, and he became perplexed as what to do to remedy the evil." The rest of the report is optimistic but with reservation:

> *The scientist is at work on these very difficult matters, and is finding the cause and the remedy as fast as it is possible to do...We should therefore give every encouragement in our power to our scientific investigators. They are working for us; they are working for the public good. The agricultural scientist and the farmer are working in cooperation* [these words were in italics to underscore their importance]; *if the work of either is crippled, the farmer's labors will be in vain, and our supply of food will be correspondingly reduced, and the insects and the blights will consume the products of the earth.*

Again, a catastrophic outcome is envisioned, which does not surprise us in view of the date of the report: it is 1909, and the world is preparing for war, creating a mindset susceptible to exaggerated fears.

Surprisingly, the 1909 report makes no reference to a scientific breakthrough of extraordinary significance. A fungicide developed in France, consisting of lime and copper sulfate—commonly referred to as the Bordeaux mixture, had succeeded in bring black rot under control. Introduced in New Jersey, the effect could not have been more striking. The amount of grapes harvested in Atlantic County rose from 1,044,000 pounds in 1899 to 2,300,000 pounds in 1909; in Cape May from 97,000 pounds to 144,000 pounds; in Monmouth County, from 281,000 pounds to 563,000 pounds. This remarkable development was duly noted by the State

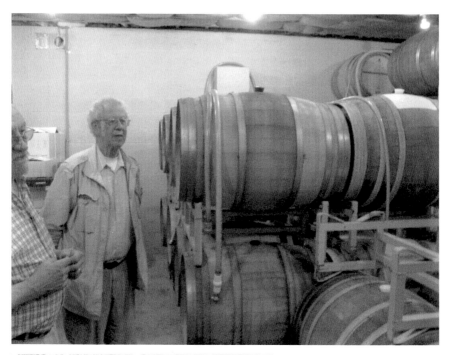

*Above*: Ventimiglia guided tour. The oak barrels…

*Left*: …and a small press.

Alba Vineyards. A pleasant view.

Board of Agriculture, which disclosed that grape growing had become the leading crop in the above three counties, that three thousand acres were devoted to grape growing and that "an experimental vineyard established in Vineland by the United States Department of Agriculture will no doubt give an additional stimulus to this industry." As nothing more is heard of the vineyard, one can assume that the project was abandoned. Some interesting financial facts are divulged: the cellars of H.F. Dewey and Sons—i.e. the Dewey Winery—contained 2,000,000 gallons of stored wine and grape juice, and grape growers could expect to realize profits of as much as $120 per ton or 18 percent on their investment. Viticulture could indeed be a highly profitable activity.

Grape growers were understandably upbeat about the future. We can cite the following account, written by Henry Feiffer, a farmer from Cologne, New Jersey, in 1907:

> *The most profitable fruit with me, all things considered, is a grape with a home market which is ready to take everything that we could grow for years*

*to come in the shape of well ripened grapes of the proper varieties. We have no freights to pay, no packages to lose, and do not need the commission merchant. A large amount of the work that is done in a vineyard—pruning, trellising, tying, manuring, plowing, hoeing—can be done in winter when other work is not pressing. It has been learned that the soil of Atlantic County, rich in iron as it is, is preeminently adapted to the culture of grapes that are rich in the special qualities so desirable in producing a wine that is a real medicine and a tonic for the sick and debilitated.*

A nod to Dr. Welch! Feiffer lists the following varieties as the most commonly planted: "Clevner, Franklin, Diogenes, Norton's Virginia, Black Nero, Clinton, Concur [a typographical error, he meant Concord], and Ive's Seedling, the last two having no value to the wine maker, except as blenders with the heavy bodied varieties mentioned above." Prices are given as $50 per ton for Ive's Seedling, $90 per ton for Franklin and $120 per ton for Norton's Virginia, a steep price but well worth paying given the high esteem with which it was regarded. The eminent French scientist Jules Emile Planchant, on a tour of American vineyards in 1873, declared the latter "excellent."

Two photographs provide invaluable anecdotal information about winemakers during the period the French aptly call la belle époque. One preserved in the Huntington Library in California is of Louis Nicholas Renault surrounded by associates, salesman and workers. A man obviously of means—he is formally attired, and a gold chain is seen hanging from his vest—the eighty-four-year-old founder of Renault winery is pouring himself a glass of wine, a gesture repeated by others, even by one of the boys sitting cross-legged in front of the group. The mood is celebratory; all are smiling except for Renault, whose expression bespeaks dignity and authority, which is to be expected from a one-time immigrant, now a successful, self-made American entrepreneur. (Or is it that he is still a Frenchman at heart and must maintain a certain distance from underlings?) He joins his employees as a fellow celebrant about to quaff down a glass of wine, a bon vivant confident that the good times will never end.

Another photograph, published in Jennifer Rignani's *New Jersey Wineries*, of the Krumm family taken in 1914 conveys a similar message of well-being, the family history not very different from that of Renault. Arriving from Germany in the middle of the nineteenth century, the Krumms were soon cultivating fifty acres of corn and lima beans in Linwood, New Jersey. In 1912, William Krumm (son of the first settler?) built a winery, having established a vineyard some years before. The photograph depicts the family

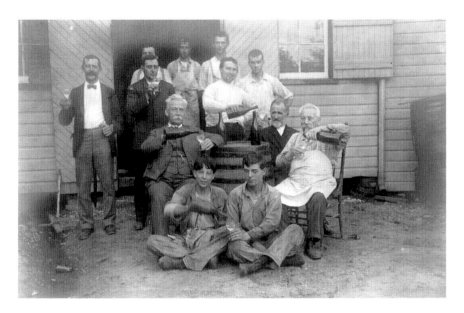

Renault family. *Courtesy of Hunnington Library.*

standing before the truck William has just purchased to transport produce to market—a sign that he has adopted modern ways, trucks being, in 1914, still regarded as a novelty. The Krumms are not wealthy but comfortably off; the men have on tailored suits, and the women wear the long dresses then in fashion. Everyone is smiling, even William's aged mother, possibly because her son is affectionately clasping her shoulders. William's wife is holding tight their youngest daughter, while an older daughter is hugging an older woman, probably an aunt. The portrait is of a close-knit German American family enjoying a spring afternoon. It might have been one of their last happy moments, for a few weeks later, on June 28, Franz Ferdinand, heir to the Austrian throne, would be assassinated in Sarajevo, precipitating a war particularly painful to Germans, who would have to confront their former countrymen in battle.

The first decade of the twentieth century was a high point for viticulturalists both east and west of the Rockies. Vineyards and wineries were proliferating and the quality of wines constantly improving, as is evident from the large number of awards won at international expositions. Thus, at the Paris Exposition of 1900, American wines garnered an extraordinary thirty-six gold medals, one of which went to the Renault Winery for its sparkling wine. American wines were now being served in the finest restaurants of New York

and Philadelphia, where they competed favorably with the best wines of Europe. The average American, however, still viewed wine as the beverage of aristocrats and immigrants, therefore doubly objectionable, preferring to imbibe beer and cider. But Prohibition was about to be legislated, banning all three.

# The Disastrous Years

## (1920-1945)

*In the early years of what would become the American century, the wealth and power of the United States began to exert unprecedented influence on cultural tastes the world over…American art, music, and fashion were beginning to turn heads abroad. Why not wine too? But then came National Prohibition and with it American wines' great fall.*
—*Paul Lukacs,* American Vintage

A great fall, indeed! A minority of Americans had succeeded in imposing their will on the majority. For a wine-producing state such as New Jersey, Prohibition was doubly onerous as it denied its citizens the pleasure of imbibing alcohol while striking a telling blow to the state's economy. Counties such as Atlantic, Cumberland and Sussex experienced a drastic decline in grape production, but surprisingly not Bergen, Burlington and Monroe, where it actually increased. As it is unlikely that New Jerseyites were eating more grapes, it must mean that they were pressing grapes and making their own wines—a conclusion supported by the fact that grape production declined in areas where better-quality grapes were being grown that were no longer in demand now that commercial winemaking had ended. Intended for one's own table or that of neighbors, friends and acquaintances, ordinary *Labrusca* varieties met the winemaker's needs. In the course of time, mutually advantageous arrangements were made with clients in neighboring communities but always on a personal basis, ethnic and linguistic ties

being particularly important in solidifying relationships. One can see why kinship organizations such as Cosa Nostra arose at this time.

From the outset, there was considerable resistance to Prohibition in New Jersey and elsewhere. The Garden State's enforcement czar, retired army colonel Ira L. Reeves, left after eight months in office, discouraged by the proliferation of speakeasies where every form of alcohol was served. (The colonel called for the repeal of Prohibition before resigning.) One such establishment was brazenly located on Chancery Lane, across the street from Trenton's police station. It was not long before acts of defiance were assuming a violent form. In January 1927, federal agents, attempting to raid a warehouse in Trenton containing cases of wine and whiskey, were met by a threatening mob. One of the agents fired a warning shot in the air, which alerted a local patrolman, who promptly arrested the agents for carrying guns without the required state licenses. Municipal crime syndicates made their appearance, each striving to extend its reach in the manner of Italian Renaissance principalities—a resemblance that extended to the presence of a potentate, the Boss.

One boss was Max Hassel, New Jersey's foremost bootlegger and owner of a brewery in Camden. Cultivating the image of a gentleman beer baron, Hassel shirked violence, telling his associates that his reputation and shrewd business sense would ensure the success of his enterprises. His rival was Mickey "the Muscle" Duffy, a thug working out of Philadelphia, who decided to expand into Camden, Hassel's turf. Adding insult to injury, the former offered to buy Hassel's brewery. When the offer was rejected, Hassel was visited by Duffy and his goons, who dragged the gentleman beer baron out of his brewery, pummeling him and declaring to all caring to hear that he, Duffy, was the brewery's new owner. A sensible man, Hassel offered to take in his rival as an equal partner, an offer that was accepted by Duffy, who thought he could benefit from Hassel's business acumen and contacts. The partnership ended two years later, when Duffy was killed in a police ambush, leaving Hassel again the sole owner of the brewery and the undisputed boss of New Jersey's underworld. The moment seemed propitious to expand. Joined by two associates, Waxy Gordon and Max Greenberg, Hassel took control of all of New Jersey's sixteen breweries, each with sales of millions of dollars, making him one of New Jersey's wealthiest men.

The question of who would supply Newark's restaurants and speakeasies with beer, whiskey and wine produced another picaresque struggle. The rivals were Ruggiero Boiardo—known as Richie the Boot because he could always be found making and receiving phone calls in a telephone booth,

the last two letters of which his associates could not pronounce—who controlled Newark's first ward, and Longis Willman, the boss of the city's other wards. The conflict began when the Boot tried to expand beyond his ward, prompting Willman to take forceful counter measures. The Boot was caught crossing Broad Street in downtown Newark and shot eight times but managed to survive. It was his turn to show resolve. Two armed men dressed as women were sent to Willman's hangout in the Riviera Hotel but were stopped by bodyguards. Willman now did something out of character. He sent the men back to Boaiardo with a truce offering. A meeting was arranged and a settlement quickly reached, with a return to the status quo ante. Thus ended what came to be known as Newark's beer war.

Bootlegging was particularly active in Atlantic City, New Jersey's premier resort, where close ties appear to have been maintained between Nucky Johnson, Atlantic City's underworld boss, and the Renault Winery, then owned by John D'Agostino. Jailed in 1941 for tax evasion, Johnson was hired by Renault as a salesmen upon his release in 1945. "Flow [Johnson's wife] worked in the gift shop at Renault while Nucky was still incarcerated," reports present owner Joseph Milza, a detail that I trust will find its way into the HBO hit *Boardwalk Empire*.

Soon after Prohibition had been enacted, it became evident that enforcement would be a daunting if not impossible feat. The target was simply too large. The legislation on which the amendment was based, the National Prohibition Act, defined an intoxicating liquor as any beverage containing more than 0.5 percent of alcohol, thereby including the relatively innocent fermented and brewed stimulants with the offending distilled ones. This greatly enlarged the policing parameter without allocating the needed additional resources in men and materials. Moreover, the degree of popular resistance and the resourcefulness and determination of the underworld had not been foreseen, thus making the cost of enforcement that much greater. The purveyors of alcohol operated along New Jersey's long coastline, but safely in international waters, loading their cargoes onto high-powered and armed motorboats. In response, the federal government extended U.S. territorial waters from three to twelve miles, thereby allowing its patrol boats to keep smuggling vessels under surveillance, effectively halting foreign supplies. The bootleggers then turned to domestic sources, fraudulently removing alcohol from the stockpile reserved for industrial use. The government's response was to alter the chemical character of the alcohol, rendering it unfit for human consumption. This did not thwart the bootleggers, who simply redistilled the concoctions or introduced

chemicals to disguise adulteration, with catastrophic consequences for the unsuspecting consumers.

Still other ways could be found to circumvent Prohibition. Employing wine in religious ceremonies and therefore protected by the U.S. Constitution, a church or synagogue could be induced for the right sum to surrender some of its stock to the underworld. And as wine also has medicinal uses, all that needed to be done was to persuade doctors to prescribe it. The government's response to the last ploy was draconian. It passed the Supplement Prohibition Enforcement Act of November 23, 1921, which provided a) that only substances containing more than 24 percent of alcohol by volume could be prescribed, but only if the amount b) did not exceed half a pint of alcohol or c) was used by patients within ten days of the onset of an illness, and that d) no more than one hundred permits could be issued by the physician within ninety days "unless having to meet emergency needs but these would have to be demonstrated to the satisfaction of the commissioners who issued such permits." A more convoluted text could not have been conceived!

Under these conditions, only the most ingenious wineries could survive. None in New Jersey displayed the deftness of the Widmer Winery in upstate New York. The following description of its offerings appeared on its letterhead:

> *Altar wines, wine tonics, wine sauces, mint sauces, wine jellies, fruit jellies, grape jellies, grape syrups, grape pomace, medical wines, grape concentrates, de-alcoholized wines, manufacturing wines, rum and brandy jellies, rum and brandy sauces, cider for vinegar stock, manufacturing wine syrups, sweet cider in glass and bulk, crème de menthe wine cordial.*

Caution was thrown to the wind when making claims. The Turner Wine Company of Toronto declared that its tonic was "especially indicated in conditions such as anemia, debility, general lassitude, loss of appetite, weakness and fainting spells, nerve exhaustion, torpid liver, and convalescence from influenza, pneumonia, and other debilitating and exhausting diseases." In New Jersey, the Krumm Winery survived by producing wine jellies, tonic and cooking wines and sherries. A 1920s advertisement reads:

> *Always a winner! Sea View Tonic Wine. The greatest stimulating and nourishing tonic placed on the market in ages. It rebuilds your system; it gives the desired pop that oft-times are lacking after a strenuous summer season! Drink Sea View Tonic now and watch for encouraging and convincing*

*developments. Port or Sherry $1.50 a bottle, $16.50 a case. Sold at all druggists and most good groceries.*

An illustration appears of a radiant young woman about to dive into water, a perfect way to rebuild one's system!

While not ignoring the medical angle, John D'Agostino of Renault preferred to emphasize his winery's historic connection with Egg Harbor. A 1930 brochure honoring Egg Harbor's seventy-fifth anniversary explained: "L.N. Renault and Sons Incorporated began making wines and champagnes here in 1870. Since that time the name Renault has been associated with Egg Harbor City for 60 years, first with wines and champagnes, and then with medicinal wines, wine tonics, brandied fruits, wine jellies and wine syrups." A municipal parade was an opportunity to promote one's alcoholic products. The words "Renault Wine Tonic" are prominently displayed on a float holding up an enormous mockup of a Renault bottle, whose appeal is enhanced by the presence of a bevy of charming young ladies. A mischievous sense of humor can be detected in the following warning, which appears in an advertisement touting the medical properties of Renault sherry, Tokay and port: "Do not refrigerate this product as it may turn to wine."

All the above stratagems notwithstanding, winemaking and distribution continued to lose ground. In *Carol v. the United States* (1925), the Supreme Court upheld the right of federal agents to search any vehicle without having to secure a search warrant. The stage was set for inter-vehicular combat, rendered particularly lethal by the use of high-caliber weapons, including machine guns. America had returned to the Hobbesian state of nature: endless acts of violence, failure at every level of government, courts so cluttered with Prohibition cases that justice could not be dispensed—all pointing to the approaching collapse of civil society. By the early 1930s, only diehard enemies of alcohol still had faith in Prohibition. One of America's most admirable traits is its willingness to acknowledge mistakes, and this it now did. On February 21, 1933, Prohibition was repealed—the only amendment to the Constitution nullifying another. In the midst of the worst depression in its history, America realized that it could no longer afford certain conceits, especially one as ill conceived as Prohibition.

When Prohibition ended, New Jersey viticulture was nearly extinct. Grape cultivation in the state had declined drastically, from 2,500 acres in 1930 to 1,100 acres in 1940; grape production had declined by more than half. Certain counties were particularly hard hit. In Cumberland County, the number of farms growing grapes decreased from 1,885 in 1925 to 102 in

1935; in Atlantic County, from 867 to 223; in Huntingon County from 1,221 to 225. Farmers were uprooting their vines on a massive scale. Most wineries disappeared, and the few that survived were in a lamentable condition: skills had been lost, techniques and knowhow forgotten and presses and tractors not kept up were rusting. Vineyards were disappearing and would require considerable time to return to life. Particularly pernicious was the radical change that occurred in the character of wine: it became excessively high in alcohol (the case of fortified wines dispensed in pharmacies as tonics) or so high in acidity that it was barely drinkable (the case of homemade wines).

These changes coincided with an alarming shift in behavior, with alcohol drinking taking on an obsessive character. What had before been exceptional now became commonplace. One had to have a drink. Hollywood was quick to dramatize uncontrolled alcohol drinking. Not surprisingly, wine drinking took on the attributes of a disreputable activity. As Thomas Pinney points out in his *History of Wine in America*: "Domestic wine had no place in middle class dining rooms or fine restaurants. Instead it belonged in paper bags on skid row. There the men drinking it were known as winos." A sign of the times was the appearance of a product known as Vine-Glo. It originated in California and consisted of a kit containing raw grape juice and a portable barrel so that customers would have the satisfaction of making their own wine. (The installation and bottling was actually the work of a national network of technicians sent out by the Vine-Glo Company in imitation of Roto Rooter plumbers.) Wine was now being produced by servicemen. How low the mighty had fallen!

The decline of grape production coincided with a decline in the production of other staples: apples, cherries, peaches, pears, carrots, peas and tomatoes. The Garden State was about to become gardenless. The future of agriculture seemed bleak indeed, and not just for New Jersey. An observer pointed out: "The growing of staples in America has become unprofitable: world competition, heavy capital charges, a protected tariff system which raised the prices of non agricultural commodities and at the same time closed our markets to the rest of other nations—these factors are attributing to the debasement of the lot of the farmer." Statistics supported such dire conclusions. Farm income in 1932 in the United States was less than one-third of the already depressed 1929 level. Hungry people are angry people, and this is particularly true of those who work the soil. The election of Franklin Roosevelt in 1932 was greeted with talk of revolution. "My candid opinion," wrote the president of the Farmer's Union to the president-elect, "is that unless you call a special session of Congress and start

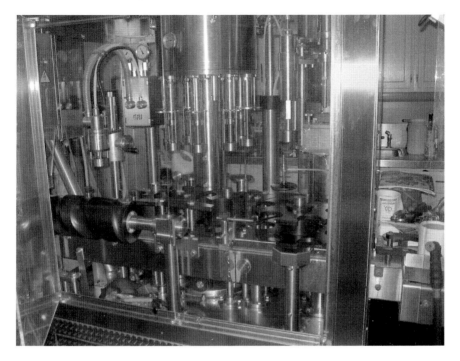

Laurita Vineyards. A bottling machine.

a revolution in Government affairs, there will be one started in the country. It is just a question of whether or not you will start one first."

Roosevelt heeded the warning, and a "revolution in government affairs" indeed took place. It was called the New Deal and produced a host of legislation favorable to farmers, chiefly the Agricultural Adjustment Act (AAA), which was designed to raise the prices of farm products and relieve farmers who were burdened by a mortgage indebtedness of $8.5 billion (a familiar state of affairs!). The plan was to take some forty million acres of land out of cultivation and to reimburse the farmers for the value of the crops they would lose by a tax levied on food processors, who would pass along the higher costs to the consumers. New Jersey farmers benefited from the fiscal maneuvers, but only until January 1936, when the Supreme Court declared the AAA unconstitutional.

For winemakers, the road ahead was particularly perilous. Prohibition had been repealed legally, but its spirit lingered. Certain restrictions on the sale of alcohol would have to be retained, as President Roosevelt admitted: "The policy of Government will be to see to it that the social

and political evils that had existed in pre-prohibition era shall not be revived nor permitted again to exist." The alcohol industry would have to be closely regulated, becoming in fact the most regulated of all American industries. The newly established Federal Alcohol Control Administration, which eventually became the Federal Alcohol Administration, was charged with overseeing all aspects of winemaking and selling. Thus, the word "cask" was not to appear on a label, for it implied that ageing had occurred, nor could wine be sold in bulk—just two examples of not-so-subtle administrative harassment.

Particularly distressing for winemakers intent on marketing their wines nationally was that states would decide whether or not to allow the sale of wine and under what circumstances. Prohibition had simply been shifted from the national to the state governments. In fact, only twenty states decided to repeal it, but even among these, rules were not universally applied. There were counties in New Jersey, a "wet" state, that chose to remain dry. Then there were states that permitted the establishment of retail outlets and others with a state monopoly system. The result was a veritable legal maze. "Both Arkansas and California were license states," relates Pinney,

> but in Arkansas you could not get wine or spirits in a hotel, restaurant or club, though you could in California. In California, on the other hand, you could buy drink at a bar, but in Colorado, another licensed state, you couldn't. You could have a drink on licensed premises only if the container held two ounces or less. In Massachusetts, women were not allowed in taverns, and in those places where women could drink, they had to be seated when they did so.

Confronting a hostile political world, the wine industry had to contend with difficulties of its own making. A manual written in 1934 has the telling title *Wine: For Those Who Have Forgotten and Those Who Want to Know*. Vintners had simply forgotten how to make wine, a state of affairs even true for California, with its long viticultural history. *Fortune* magazine was particularly harsh in its criticism of the Golden State:

> *Most California Riesling, best of the white wines, is watery and just something to drink with your fish; white wines, the Claret and Burgundies and the Chianti's have neither the authentic flavors of the original nor the strong honest qualities of the wines we bought last year* [that is, during Prohibition]. *Most California wine, in short, is belly wash.*

# The Disastrous Years

The most elementary rules had to be relearned; for example, that wines can be spoiled if kept in unclean barrels. Straining credulity is Pinney's disclosure that barrels formerly used for vinegar, pickles, glue, molasses, lard and oil were used to store wine. One cannot be surprised to learn that Americans were spurning wine in droves. In California, consumption averaged only three gallons a year; in New York, three-quarters of a gallon; and in Missouri, one-quarter of a gallon. There was also a change in the type of wines Americans were drinking. Before Prohibition, the country had favored dry wines in a ratio of three to two. The proportion was now reversed. And it was not just sweet wines that Americans preferred but also heavily fortified ones with an alcoholic level often exceeding 20 percent by volume.

While most New Jerseyites welcomed the repeal of Prohibition, a significant number did not, with 10 percent of the state's counties voting to remain dry. In the southern counties, where grape growing had always been an important activity, the repeal was enthusiastically received. A photograph in Rignani's *New Jersey Wineries* depicts a group of Egg Harbor citizens celebrating the event. All are well dressed and have arrived in automobiles, evidence that they are stalwart members of the community. The spirit is festive: an accordionist is performing and a young woman is perched above a barrel of Renault, which is being carried by a horse-drawn cart—reminding us who is behind this celebration—while a policeman watches benevolently as wine flows out of the barrel. The good times have returned! A measure of popular sentiment can be gauged from the rise in the number of wineries that followed the repeal of Prohibition. Charles Tomasello is fond of relating that his grandfather Frank took off for Washington, D.C., as soon as he learned that the Twenty-first Amendment had been ratified so that he would be the first to apply for an official license.

From the outset, the New Jersey authorities made clear their intention of keeping the wine industry on a short leash. Legislation was quickly passed to limit the number of wineries to no more than one per million inhabitants (why this particular ratio is not clear), the sale of wine was restricted to licensed establishments (unlike the situation in Europe, where wine can be purchased anywhere), a steep excise tax was levied on wines produced in the state and an agency, the Alcohol Beverage Control Board, was created to oversee all aspects of winemaking and selling in the state. New Jersey was simply following guidelines set by the U.S. Congress, which was particularly concerned with the possibly resurgent underworld. Congressman Thomas Henry Cullen of New York must have had New Jersey in mind when he

declared, "Legalized liquor cannot be effectively regulated if the door is left open for highly financed groups of criminals and racketeers to enter into the business of liquor production and distribution."

Only three New Jersey wineries survived Prohibition: Renault, Kluxen and Dewey, with Tomasello soon joining them. Of these, Renault was the largest, producing 100,000 cases of champagne and 400,000 cases of wine annually. Its success was due to the visionary and far-seeing policies of John D'Agostino, who made sure that the winery was kept at the cutting edge of technology and business practices. It was the first winery to hire a full-time chemist, the first to use the assembly line for corking and labeling, the first to employ a sales force and the first to recognize the importance of advertising. Gigantic Renault bottles lined the highways of Massachusetts, Florida, Pennsylvania and, of course, New Jersey. One stood above the Renault tavern on the boardwalk at Atlantic City. Parades in Atlantic City celebrating the Miss America beauty pageant invariably included a float carrying a Renault mockup of a bottle of champagne. As his vineyards did not produce enough grapes to sustain large-scale wine production and the grapes he did produce were deficient in sugar, D'Agostino, ever a shrewd businessman, arranged for wine to be shipped from California, which he then mixed with his wines. To reduce costs, he went one step further and purchased two California wineries—Saint George Winery in Fresno and Fountain Winery in Saint Helena—and had their wines shipped in tank cars to New Jersey.

Thus was born the ever-popular Château Renault American Champagne with its offshoots: Renault Blueberry Duck, Gourmet American Champagne and Château Renault Cold Duck. Renault was also famous for its still wines typically fortified: sherry, port, vermouth, orange bitters, Sauternes and Chablis (D'Agostino had no scruples employing French geographic designations). The recipe for sherry may be found in Rignani's *New Jersey Wineries*. Dated August 21, 1934, it lists the following ingredients under the heading of sherry wine: 14 percent—0.5 grams of citric acid, 0.1 gram of tannic acid, 7 grams of sugar, 0.6 potassium bisulphate; also, water and wine (the variety not indicated). Then there was orange bitters, a cocktail of caffeine, phenolplithalein, sodium glycerophosphate crystals, saccharin, alcohol, water and fresh orange peel. With an alcoholic content of 44 percent by volume, the concoction was at the upper end of the alcoholic scale, therefore competing with rum and whiskey. Renault, at least in the years following Prohibition, did not produce wines that could accompany one's dinner, a void that was filled with soft drinks or beer, both of which were likely to increase the incidence of diabetes, obesity and heart diseases.

Villa Milagro. A cozy but proud interior…

…and the barrels

Having survived Prohibition and the Great Depression, New Jersey winemakers had to contend with the calamity of World War II. With the large number of Italian Americans engaged in winemaking, America's declaration of war against the Axis powers was doubly painful. Vineyards would have to be neglected or abandoned and war waged against one's kinsmen. In one sense, however, the war had a potential boon. The disappearance of French and Italian wines from fine restaurants and wine shops meant that the way was cleared for the emergence of American wines. But for this to occur, better-quality grapes would have to be grown—the *Vitis vinifera*—and the art and science of winemaking would need to improve drastically. There were two regions that should have been able to accomplish these feats: California and New Jersey. But each for different reasons did not do so. And so, once the war was over, the shelves of wine stores were again stocked with mediocre American wines, with European wines gradually returning to their prewar dominance.

# *Survival*

## (1945-1980)

Soon after the war ended, William Dewey, owner of the venerable winery bearing his name, was prepared to throw in the towel. "We Deweys," he told a reporter in 1950, "feel like letting some younger fellow take over." No one took over, and two years later the winery closed its doors. Farming in general was in crisis, not having recovered from the Great Depression. Far from being discouraged, Willard H. Allen, the New Jersey secretary of agriculture could foresee a promising future thanks to the "successful direction and efficient operation of New Jersey farmers." Allen was reflecting the views of the U.S. Department of Agriculture, which, in an assessment of the prospects of the American wine industry after the repeal of Prohibition, warned of the dangers of not adopting the ways of science:

> *If the resumption of wine manufacture in the United States is to result in anything other than a repetition of past history with a resultant flooding of our markets with an inferior product which is discriminated against by purchasers in favor of foreign wines, the inclination and continuance of a strong program of research for the guidance of the industry into scientific methods of production is absolutely necessary.*

This was the mid-twentieth-century American way of resolving all conundrums: finding panaceas in science proclaimed in such corporate slogans as "Better living through chemistry" (DuPont) and "Science for a better life" (Bayer). Faith in science was perfectly understandable, for how

could one question a discipline that had mastered the atom and released its power so effectively over Hiroshima and Nagasaki?

New Jersey did not lack true believers in the ways of science. One was Floyd W. Parsons, who in *New Jersey: Life, Industries and Resources of a Great State*, published in 1928 but with a message that resonated in the 1950s, hailed science as the gateway to progress and prosperity. He wrote enthusiastically:

> *Ours is a nation on wheels and the space above us has been transformed into a carrier of music and speech. We navigate the air, take pictures of the inside of our bodies, broadcast photographs and photograph music. We refrigerate with heat, rear oysters from artificially fertilized eggs and measure the length of thought waves sent out by the human brain, we make furniture out of steel, sugar from corn and motor oil from molasses.*

Agriculture was on the verge of a remarkable transformation:

> *Farming is on the way to becoming a highly automated and technical profession. The benefits of cheap heat and power to the industries of New Jersey will be duplicated in the State's agriculture. Electric lights are already being used to get the hens up earlier on winter mornings and thereby increase the production of eggs…Various kinds of rays will be employed to treat seeds to bring about the increased yields. Ordinary manufactured gas will speed up the ripening of fruit and probably aid in developing higher sugar content in such things as melons. Recent studies have shown that when this substance—sodium thiocyanite—is employed as a dilute solution, it speeds up the germination of potatoes that have been sprayed or dipped. This means that the farmer can market his potatoes earlier and get more money for them.*

Ah yes, the profit motive! Parsons ends with claims that manage to be both grandiose and alarming: "A mere handful of scientists, just a few thousand out of two billion humans, now holds within their grasp the destiny of humanity. Race betterment is only just commencing in real earnest. In this thought lies a serious threat to all those branches of business where the leaders stubbornly persist in opposing the forces of change." Did Parsons know that he was expressing the thought of a rising German politician, namely Adolf Hitler?

A sign that winemakers had decided to follow the path of science was the founding, in 1950, of the American Society of Oenology, committed to

a rigorously scientific approach in both viticulture and winemaking. Such was also was the avowed goal by the recently reinvigorated Department of Viticulture and Enology—the favored American spelling—at the University of California–Davis. It urged viti-viniculturalists to study temperature ranges before planting any vines, thereby ensuring adequate degree days; graft cuttings on specially selected rootstock, such an AxR-l, known to produce higher yields; vinify at lower temperatures in specially designed steel tanks; and induce malolactic fermentation with specially designed yeast cultures. A leading proponent of these and other scientific notions was Maynard Armerine, a professor at Davis, who did not mince his words:

> *We always started in with the basis that winemaking is a branch of biochemistry and grape growing is a branch of genetics and plant physiology. If you don't know anything about plant physiology, you don't know anything about grapes. If you don't know biochemistry, you don't know anything about wine. Therefore, you have to study wines from the biochemical point of view, and you have to study grapes from the genetic and plant physiological point of view in order to develop new techniques of doing things. Applied research comes out of or is based on the basic research.*

Is Armerine hyperbolic? Plant physiology and biochemistry are certainly important disciplines, but can one say that without them "you don't know anything about grapes or wine"? Did eighteenth-century Bordeaux winemakers whose wines captivated Thomas Jefferson know nothing of their craft? Are perceptive eyes and sensitive palates and noses of no use when making critical winemaking decisions? I hardly think so.

The guidelines advocated by Armerine and his colleagues found a receptive audience among California viticulturalists engaged in large-scale production, an activity made possible by a large pool of migrant workers and the infusion of vast amounts of corporate capital. As a result, an industry that has largely consisted of family-owned wineries was soon transformed into impersonal corporate holdings. The change can be traced to special circumstances existing during World War II. Compelled by the U.S. government to halt whiskey production, the country's two largest producers, Schenley and National Distillers, hoping thereby to keep their distributors occupied and retail shelves fully stocked, decided to enter the winemaking business. They went on a buying spree and before long owned a quarter of all vineyards in California. Knowing nothing about

A vineyard "scarecrow."

winemaking, what they produced was famously mediocre. Fortunately for the future of California wines, the two distillers withdrew from winemaking as soon as the ban on whiskey production had been lifted. However, far from abating, the trend to corporate gigantism intensified. In April 1945, the Italian Vineyard Company, the world's largest grape producer, sold its five thousand acres to a rising viticultural power, Garrett & Company. The scope of operation can be gauged from the following data: United Vintners had a storage capacity of 95 million gallons, a figure surpassed by the Gallo Brothers, with room for 100 million gallons. The Di Georgia Wine Company employed thirty concrete tanks, each with a capacity of 60,000 gallons; two blending tanks, each holding 260,000 gallons; and eight refrigerated tanks containing 60,000 gallons.

New York State, the nation's second-largest wine-producing state, followed California's example but on a more modest scale. With large holdings in the Finger Lakes, the Taylor Company produced what owner Fred Taylor called

"uncomplicated" wines; that is, sweet wines. The year 1972 was a banner one, with the company producing a staggering ten million gallons. Four years later, it was sold to Coca-Cola, which saw an opportunity to do for wine what it had done so successfully for soft drinks: create a global market. The strategy would have worked except for the fact that by the 1970s Americans were beginning to turn away from "uncomplicated" wines. Taylor was sold and resold and eventually ended up as a subsidiary of the Canandaigua Company, a one-time small Finger Lake winery that had become prosperous by selling a fortified sweet wine called Richard's Sweet Irish Rose. Canandaigua eventually shifted its operations to California, buying up wineries and vineyards—one suspects Wall Street's involvement—and soon was producing more wine than Gallo, a family-owned giant.

New Jersey wines in the 1960s and '70s thus had to contend with three formidable competitors: French high-quality wines, the increasingly popular California dry wines and, at the low end, New York sweet wines. Lacking a clearly defined market niche, New Jersey wines were ignored by wine stores, forcing wineries to rely on self-generated sales, hardly the most effective way to market one's wines. To meet these challenges, New Jersey could boast a total of seven wineries, with only two, Renault and Tomasello, producing significant amounts of wine and that often with grapes grown out of the state. However dire the situation, a glimmer of hope existed. As most were modest in size, New Jersey wineries were less likely to employ laborsaving mechanical devices; therefore, harvesting tended to remain a hands-on activity, an absolute requirement if quality wines are to be produced. (Renault and Tomasello employed mechanical harvesters with predictable results.)

With small wine production—and that generally of poor quality; hand picking is not a guarantee of quality when inferior grapes are being pressed—New Jersey viticulture had become a mere footnote. But inconsequence is not without advantages. Most New Jersey wineries, for the most part, were able to escape the vapid commercialism characteristic of the post–World War II years, thereby managing to preserve a degree of integrity. But more cannot be said, for the wineries were in no better shape in the 1960s than they had been in the 1940. Four of the seven disappeared before the end of the 1950s, leaving no traces of their previous existence—a grievous historical loss, particularly in the case of the century-old Dewey winery.

Of the three surviving wineries—Renault, Tomasello and Kluxen—the first is of particular interest, being the largest in the American East; it is also the only winery to have preserved a pictorial and written record. Published in

Rignani's study, the Renault photographs project cheerful insouciance, but the subtext could not be more forlorn: a venerable winery forced to adopt the most banal and tawdry ploys in order to survive. A 1956 photograph taken of the Miss America beauty pageant held annually in Atlantic City depicts a float in the form of a merry-go-round on which is standing a group of lovely young women all dressed in white gowns and waving demurely. (It is, after all, the 1950s, and emotions must be kept in check!) Two white horses are also present, completing a tableau that could not be at the same time salacious and salubrious. Another float celebrating the 1970 Queen of the Grape Harvest Festival again features lovely women, although this time coiffed with pigtails and wearing country dresses, in keeping with the back-to-nature look then in fashion. (They are, however, wearing high heels, spoiling the effect.)

Still another photograph attracts our attention: three businessmen sitting in a nightclub enjoying a glass of Renault champagne, an open bottle resting in a cooler before them. On the back of the photograph, a handwritten note explains:

> *This club is owned by Mr. David, who is shown in the picture with us. Mr. David had dinner and promised to put a Renault Champagne Cocktail Hour on every afternoon from 2 to 5 p.m. and give Renault preference within his club. He purchased 25 cases of Champagne and Sparkling Burgundy before my arrival and gave us orders for another 25 tonight. Money spent in this account will definitely pay dividends.*

One hand washing the other, the very point made by the vice-president of the Dennis Hotel of Atlantic City in a letter to Mary D'Agostino, Renault's then owner, thanking her for her support—presumably in the form of donated champagne—at a bon voyage party at his hotel: "You have been very kind to us and we like to give credit where credit is due so we try to get your name before our guests as much as possible."

Aiming to reach the mass television audience, Renault hired Johnny Carson, the then most popular television entertainer in the United States. A publicity poster was to be placed in liquor stores showing a smiling Carson standing behind a bottle of Renault American Champagne, the text reading: "Hee-ee-re's Johnny Carson and the *Tonight Show* leading Renault's big holiday Champagne promotion" and in small letters, "Powerful...full color televisions spots, Big...Bright...Colorful television spots. Selling the century-old house of Renault for you." Promotion at Renault had become a

fine art, with no attention paid to the issue of wine quality. The critical point was brand recognition, repeating the same absurd message until it shapes our thoughts and spending habits. Here's Johnny, indeed!

The Renault photographs are a telling commentary on mid-century American society, its values, aspirations and preoccupations. A 1960s photograph taken of the seventy-man Renault sales force standing and sitting before a ten-foot bottle of Renault champagne is particularly illuminating. All are dressed in suits, a sign of the seriousness with which they viewed their calling. A fact stands out: the absence of women and African Americans. Wine selling is decidedly a white man's calling. The portrait is of a certain America: prosperous, secure, confident in itself and in the country's future. And indeed, there are many reasons for optimism, for was not America the most powerful and wealthy nation on earth, the envy of the world? But as a philosopher noted, the owl of Minerva begins its ascent at dusk. Unbeknownst to the smiling, well-fed faces, historic forces have been unleashed that will challenge all assumptions, including those concerning the making and selling of wine. A world is ending, and a new one is about to be born, changes blowing in the wind.

Grape production in New Jersey, which had been declining since Prohibition, was on the verge of disappearing by the 1970s. Only 320 acres of grapes were under cultivation, mostly of the table variety—evidence that most of the wine being produced came from out-of-state grapes, most likely from California, or that the wine was simply shipped in bulk from California and blended and bottled in New Jersey. As to quality, there was nothing to distinguish New Jersey wines from the mediocre wines produced in California or elsewhere. This did not prevent a certain pretentiousness. Renault produced an impressive assortment of wines, claiming to replicate Riesling, Chablis, Sauternes, Tokay, Muscatel, Madeira and the ever-popular fortified inebriants. Aptly dismissed as "plonk," these concoctions were ideal for inducing an intoxicating buzz or more and therefore not unwelcomed at one's dinner table. The biggest sellers continued to be the champagnes, no celebration in New Jersey being complete without the popping sound of a Renault bottle being uncorked.

With the plight of New Jersey wines eliciting nothing but public indifference, the state government saw no reason to change existing legislation. The number of wineries continued to be restricted to one for each million inhabitants, and wineries could not produce more than five thousand gallons of wine from New Jersey grapes without obtaining a special license—a provision hardly designed to encourage grape growing. Grape

growers were understandably disheartened, one lamenting, "Grapes, which have caught the imagination of many in New Jersey from colonial days have never been a great success here." The *Philadelphia Inquirer* assessment was no less pessimistic: "Winemaking is not to New Jersey what poultry is to Delaware or what steel once was to Pennsylvania. The climate is too damp, land too expensive, development too pervasive." The article went on to cite the views of Ernest Christ, a fruit specialist at Rutgers University, who doubted that "New Jersey would ever produce a wine competitive with California wines…The greatest difference is a lot of sun in California."

Skepticism concerning the prospects of New Jersey viticulture soon assumed the character of a popular myth. Jack Tomasello of the Tomasello Winery ruefully declared to a reporter, "You can grow quality grapes in New Jersey. People don't realize that…I'll be on vacation and tell people what I do. They say, 'What? Grapes in New Jersey?' It doesn't sound right. But you can grow grapes pretty darn well there." He was not asked to explain why neither his grapes nor his wines were familiar to the general public, but if he had, he probably would have blamed competition from California rather than the variety of grapes he was growing. There was an obvious solution to the problem of name recognition: producing the well-balanced dry wines that Americans were increasingly favoring. But this would have required the replanting of vineyards, replacing the French-American hybrids with *Vitis vinifera* varieties. The solution was not adopted. Except for Sylvan Farms, New Jersey wineries were content to grow the safe French-American hybrids or labrusca such as concord.

The 1960s, one must remember, was a time of mass travel—planeloads of tourists to France discovering the dry French wines, which they now demanded upon returning to the United States. An important statistic: in 1967, for first time, the sale of dry wines in America equaled that of sweet ones. The far-reaching implications of this change in American drinking habits were not lost on Robert Mondavi, the future California winemaker. Paul Lukacs relates in *American Vintage*: "Sitting in La Pyramide, the legendary Vienne country restaurant, Mondavi found himself reflecting on the power of food and wine to transport us into a world of gentleness and balance, of grace and harmony." The experience, he later recalled, "epitomized the artistry and esthetics I had been discovering in Europe…Whether in art or architecture, food or fashion, this Europe prized good taste, which means the ability to make subtle distinctions, to know what to value and why." That night, he resolved that one day he would make wines that possessed "grace and harmony." It took him nine years before he could realize his dream. In

# Survival

Deer are not welcome visitors at vineyards.

New Jersey has a long agricultural history. This vineyard was once a dairy farm.

1971, he opened the Mondavi Winery at Oakville, the first new winery to be built in California since the repeal of Prohibition and the first designed to produce wines that could compete with Europe's best.

Other Americans had gustatory epiphanies similar to that of Mondavi. In 1967, this time in a Parisian café, Robert Parker, the future wine critic, experienced what he called a "revelation" while drinking his first dry wine. He liked its taste, finding it to be "the perfect accompaniment to food, and in those days it was even cheaper than Coke." At home, it turns out, he had always drunk soft drinks with his meals. Two future chefs had similar revelatory experiences. Eating fresh oysters and sole meunier and sipping a pale Chablis in a Parisian restaurant, Julia Childs felt "an opening up of the soul and spirit." Alice Waters the California pioneer in nouvelle cuisine, had a no less intense reaction while eating in a country inn in Brittany, a dinner that ended with applause and shouts of "C'est fantastique!" A veritable "communion of love…I've remembered this dinner a thousand times."

Significant cultural shifts, such as alterations in eating or drinking habits, often come on the heels of profound social and economic changes, which was certainly evident the 1960s and early '70s. Mass demonstrations, as we recall, challenged the established order, identified by President Eisenhower in his last message to the nation as the "military-industrial complex." The hyphenation should have been extended to include techno-science, a confluence of research facilities, think tanks, government advisory commissions and legions of scientific and engineering consultants without whose involvement neither the military nor the American economy would have performed optimally. Interlocked as they were, condemning one necessarily meant condemning the others. But more was involved than uncovering collusions between segments of the power elite. There was also the damage inflicted on the environment by chemical insecticides and fertilizers. Ecologically minded winemakers in the 1980s and '90s came increasingly to reject chemical or mechanical intervention in favor of natural and sustainable procedures, a trend that culminated in the creation of biological wines.

While New Jersey wines were struggling to survive, those of California were flourishing, a consequence of massive investments. Twenty investment banks were listed on the New York Stock Exchange hankering for California wineries. There was a spade of acquisitions: Schlitz Brewery buying Geyser Peak Winery, Southdown Corporation acquiring San Martin, Beatrice Food taking over Brookside Winery, Coca-Cola acquiring Franzia. Wall Street was clearly paying close attention. It was in such circumstances that an event occurred that propelled California wines into global preeminence and New

Jersey wines a step closer to extinction. George Taber, a *Time* correspondent, called it *The Judgment of Paris*, the title of his lively book, because it took place in the French capital, although the not-so-subtle allusion to the incident that precipitated the Trojan War was not lost (was Taber suggesting that a war in the wine world was about to erupt?).

The date was May 24, 1976. The site was the celebrated Intercontinental Hotel, where twenty wines, twelve from California and eight from France, evenly divided between chardonnays and cabernet sauvignons, were judged in a blind tasting. The results were startling. Among the chardonnays, Château Montelena of California came in first, defeating Meursault Charmes, while among cabernet sauvignons, Stag's Leap Wine Cellars, also of California, took top honors, winning over the Château Mouton Rothschild. The participants were astounded, as were the millions of *Time* magazine readers who learned of the tasting a few weeks later when George Taber's article appeared with its epic pronouncement, "California defeats all Gaul."

Robert Mondavi could not have been more jubilant, as he relates in his autobiography, "The Paris tasting was an enormous event in the history of California wine making. It put us squarely on the world map of great wine making regions. I saw the impact everywhere I went. Suddenly people had a new respect for what we were doing. They saw we could make wine as good as the best of France." Robert Parker was no less exultant but insisted on seeing the event in a political light: "The Paris tasting destroyed the myth of French supremacy…[and led] to the democratization of the wine world. It was a watershed in the history of wine."

A watershed in the history of wine! So extraordinary a claim invites a closer look at the event. First, concerning the makeup of the jury—of the nine judges, two were wine industry administrators, two owned restaurants, one was a wine editor, another was a sommelier and there was a winery owner, a teacher of wine courses (who posed as the president of the nonexistent Institut Oenologique de France) and a sales director of a publishing house who had not previously been on a wine-tasting panel. All—well, nearly all—were honorable individuals with close ties to the wine world. However, not one was an academically trained enologist. The number and selection of wines also invite criticism. There was a six-to-four imbalance in favor of the American wines, giving these an unfair numerical advantage. And then the wines were chosen by Steven Spurrier, the organizer of the event, rather than some impartial individual. Two of the Bordeaux reds, Château Montrose and Château Leonville, Taber discloses, were chosen because they were Spurrier's favorites, a strange way of choosing wines for so important an

event. One cannot but wonder what the outcome would have been had such first growths as Château Margaux and Château Lafite been selected. With three of the top four places being won by Bordeaux reds, an improvement in quality, however slight, would have given them a sweep—Gaul therefore defeating California.

One must also raise the question of the vintages selected, particularly when planning a contest that includes Bordeaux red wines. Spurrier was constrained to select wines produced between 1970 and 1973 because few, if any, of the California wines existed before them. The Bordeaux reds were therefore not at their best; the consensus is that it takes at least a decade for Bordeaux reds to reach their prime. Taber's rejoinder that "even in its youth a great wine shows its greatness," is questionable in our view. It must also be noted that the tasting was conducted in a circus-like atmosphere. There was much laughter, witty outbursts and so much chattering that one of the judges later complained that he had to found it difficult to concentrate; anyone witnessing the event would have been justified in concluding *cela n'est pas sérieux*, one of the harshest criticisms that can be leveled in France. In such circumstances, a handful of wineries in existence less than a decade toppled a two-millennia-old craft consisting of thirty thousand members, and all this in less than three hours! The French were understandably bitter.

The Paris tasting proved to be more than the consecration of California wines. It signaled the emergence of a global wine culture and taste. Two dozen California wineries producing more than 90 percent of the state's output set about creating a replicable wine that eschewed extreme sensations—therefore, the possibility of being memorable—a wine notable for its predictable sameness, pronounced fruitiness and uneventful aftertaste; in short, a pleasant beverage appealing to all, possibly even to soft drink junkies. California wines became the model that other wines tried to copy, Napa Valley becoming the lodestone of winemaking throughout the world. Among the mimics was Languedoc Roussillon, which produced such California-inspired disasters as Fat Bastard and Red Bicyclette.

New Jersey winemakers in the 1970s were not unaware of what was taking place on the West Coast. But any thought of overtaking or even competing with California would have been dismissed as quixotic or worse. After all, there was California's Edenic climate, so different from that of New Jersey. (That New Jersey's climate resembled that of Bordeaux was not given serious thought.) New Jersey's goal could not have been more modest: simply to survive, which meant producing the sweet wines for which there was still solid demand. There was therefore no need to venture beyond the pale of

*Left*: Alba Vineyard. An unusual award…

*Below*: … and room for more.

French-American hybrids. There was, however, a dissenter: Frank Salek of Sylvin Farms, who toward of the end of the 1970s began cultivating *Vitis vinifera* varieties, the first sign of a change in New Jersey's viticulture, one that was soon to transform the state's wine industry.

# Rebirth

## (1980–1990)

The resurgence of New Jersey winemaking began with the Farm Winery Act enacted by the New Jersey legislature in 1981. Any farmer with three acres of grapes under cultivation could apply for a limited license, which accorded him the right to produce up to fifty thousand gallons of wine annually. The effect could not have been more dramatic, with the number of wineries rising quickly from seven to eleven.

A fact to be noted is that many of the new wineries had previously been failed farming ventures. The Delvista Vineyards of Frenchtown had been an abandoned chicken hatchery; Anduzzi's Winery of Delran Township, a vegetable farm; and Alba Vineyards of Milford, a one-time dairy farm. Grape growing and eventual winemaking seemed a sensible way to restore a farm to productive use. But intangible emotional factors may have lurked behind the decision to embark on so hazardous a course of action, for many of the new proprietors were urban professionals who had lost contact with the verdant world and who yearned (we surmise) to reestablish that link, to realize long-deferred dreams—aspirations altogether praiseworthy but unrealistic. For could individuals who had never grown grapes or made wine hope to succeed in activities so demanding and complex? A high rate of failure was therefore certain. Indeed, more than half of the new wineries failed within a few years.

What might be called the quixotic phase of New Jersey's viticultural revival had ended with many setbacks but also some notable achievements. At the International Wine Competition held in Rochester, New York, in 1984,

Alba Vineyard. A floating bird chaser…

…and Alba's portico.

Rebirth

Tewksbury Wine Cellars won a gold medal and Best of Class designation for its 1983 Chardonnay, defeating forty other Chardonnays, including some from California. Silver medals were also won at the San Francisco and San Diego State Fairs. The failures were not without value, for important lessons could be learned from them: the hazards of cultivating *Vitis vinifera* grapes (no longer because of Phylloxera but because of unfavorable weather conditions), the importance of vinifying in new rather than used oak barrels and the necessity of an effective marketing strategy. One senses the onset of a new realism in viticulture, no doubt reflecting the new realism prevailing in the culture at large: adopting a more deliberate and cautious approach so as to not repeat errors and the resolve to confront challenges, however daunting. There is Rudolf Marchesi's forceful pronouncement made to a reporter: "I don't want anything to do with labrusca. I make dry table wine that is very different from what has been happening in New Jersey in the past." Also Louis Caracciolo's more reflective but no less defiant conclusion: "The idea that fine wine could not be produced in New Jersey was a superstition to me. I know that with proper knowledge and commitment we could and can produce award-wining wines." And Frank Salek's audacious claim: "We can grow the finest varieties of grapes which should mean that we should make the finest of wines in time."

Making the "finest of wines" was a novel idea in the early 1980s; no one had seriously considered producing such wines in New Jersey for two hundred years. But to produce wines of quality, winemakers would have to follow Salek's practice of planting *Vitis vinifera*. Resistance came from the established wineries, a skeptical Charles Tomasello of Tomasello Winery remarking: "Its high-stakes poker. Labrusca varieties still pay the rent." Financial considerations were likewise paramount at Renault Winery, acquired in 1977 by Joseph Milza, a publisher and businessman. Knowing little of grape growing, Milza took the safe path of continuing the Renault practice of cultivating native American varieties, particularly Concord, Catawba, Elvira, Niagara and Noah. *Vitis vinifera* varieties are notably absent, such grapes being shipped in from California to meet the modest demand for dry and semi-dry wines. (Did Renault still own two wineries in the Golden State?) Milza's intention from the outset was to transform Renault into a financially successful enterprise. (The winery had been in decline since Prohibition.) In addition to wine selling, he opened three restaurants on the premises, one of which was large enough to accommodate three hundred guests; a golf course; and a well-stocked gift shop meant to entice bus travelers on their way to Atlantic City's casinos. Winemaking at Renault

had become just another activity, although still representing a significant source of revenue, with annual sales of about fifty thousand cases a year. The biggest sellers continued to be blueberry-flavored champagne, sparkling Burgundy, pink Catawba and white Fresselo, a blend touted as "good for wine coolers."

The mid-1980s was a time of change in New Jersey's wine industry. The Farm Winery Act was amended in 1985 to allow wineries to sell their wines at wholesale and retail outlets if at least 51 percent of the grapes pressed originated in New Jersey, and this during a period of no less than five years, after which New Jersey grapes would have to be used exclusively. Passage of the legislation resulted in another increase in the number of wineries, rising to sixteen by 1987. Beginning to make waves, the wineries decided to form an organization to promote New Jersey wines—the New Jersey Wine Growers Association—electing Louis Caracciolo as its first president. This was followed by the establishment of the New Jersey Wine Industry Advisory Council, comprising winemakers and state officials charged with disbursing a portion of the state tax on wine for worthwhile marketing projects. The state government was now intent on advancing New Jersey wines. Ronald Good of the Department of Agriculture observed, "The winemakers in New Jersey are taking a serious approach to winemaking; they are dedicated to their craft and are constantly striving to improve the quality of their wines." The same point was made by Governor Kean in early 1987 in the form of a proclamation:

*WHEREAS commercial grape growing and wine making contributes more than 5 million dollars annually to the State's economy and enhances the Garden State's overall agricultural productivity and diversity; AND WHEREAS, grape growing and wine making is an Agricultural activity which dates back to New Jersey's early settlers and has remained a viable agricultural activity in New Jersey for 200 years; AND WHEREAS, New Jersey presently ranks 7ᵗʰ in the nation in production of award winning wines; AND WHEREAS, New Jersey's 16 commercial wineries and many of its grape growers encourage public visitation and tours of their farm operations; organize frequent public events; and thereby educate the public about agriculture and food production; AND WHEREAS, it is appropriate that all New Jersey citizens appreciate and understand how the wine industry fulfills consumer demand and helps to preserve farmland for the benefit and enjoyment of future generations; now therefore, I, Thomas H. Kean, Governor of the State of New Jersey, do Hereby proclaim May 11–17, 1987 as New Jersey Wine Growers Week.*

# Rebirth

It had taken New Jersey more than five decades to formally acknowledge the folly of Prohibition. But the state went far beyond admitting a mistake. For in asserting that "the wine industry fulfills consumer demand," it recognized wine's salutary and life-enhancing properties, thereby forging a cultural link with the Mediterranean world, motivated to do so not because New Jersey's citizens or their forebears had originated in that region—although many did—but rather because it wished to appropriate the wisdom flourishing on its sea shores: the view that life is ultimately a celebration, a joyful life-asserting dance made that much more elemental after a glass or two of wine. Dionysus could not have been more pleased!

Sensing a scoop, the *New York Times* sent its wine editor, Howard Goldberg, to investigate. He reported, "Recently I spent two days mostly in barns turned winery, sampling seven vintners' whites and reds made from classical vinifera grapes and French-American varietals. I found sophisticated winemaking, encouraging experimental groupings and some flops." The last point not withstanding—are there not some flops in Napa Valley or St. Emilion?—the word was out that serious winemaking was occurring in New Jersey. In less than a decade, a band of fearless winemakers had transformed a nondescript winemaking activity into a vigorous and ever-expanding industry. No doubt part of the reason for this epochal achievement was the will and vision of its winemakers, but a viticultural development of the first order must not be overlooked: the decision to cultivate French-American hybrids, among them Chancellor, Chamboursin, De Chaunac and Baco Noir. Lacking the velvety smoothness and balanced quality of wines made of *Vitis vinifera* grapes, they are also devoid of the excessive acidity and disagreeable foxiness of wines made of *Vitis labusca* grapes and are therefore a perfect compromise between excellence and execrability! Their French provenance made their appeal that much greater, France having the reputation, since the days of Pasteur and probably before, of being at the forefront of viticultural innovation. (Americans did not know that by the 1950s the French had banned the cultivation of hybrids, claiming that the wines they yielded were medically dangerous.) Suddenly, New Jersey wines had become drinkable, sufficiently so that they could accompany one's dinner. Unexpectedly, there was also a change in drinking habits; wines were drunk not as in Prohibition to achieve inebriation but to enhance the pleasure of the table, eating and drinking taking place in quality restaurants, whose numbers proliferated in the 1980s. California was again in the lead, but New York, Pennsylvania, Virginia and New Jersey were gaining ground.

How did French-American hybrids reach New Jersey? In fact, why had they even come into existence? Their story is tied to the Phylloxera blight in mid-

nineteenth-century France, which had the effect of forcing grape growers to choose between grafting vinifera vines onto labrusca stock or planting hybrids. The former was time-consuming, and therefore more expensive, and there was the uncertainty as to which stock to employ—whether labrusca, rotundifolia, rupestris or riparia. French viticulturalists were therefore disposed to plant hybrids, calling the vines *producteurs directs*, as they grew on their own roots. But what kind of hybrids? Not the existing American hybrids—Delaware, Catawba, Isabella—which were deemed deficient in sugar and tannin. The only recourse was to create new varieties, crossing French and American vines, hence their name. It would not be an exaggeration to say that French-American varieties saved French winemaking before doing the same in the American East.

The new hybrids began to arrive in the United States after World War II thanks to the efforts of a gifted and far-seeing viticulturalist, Phillip Wagner. A correspondent for the *Baltimore Sun* in England in the 1930s, Wagner had been impressed with the quality of wines made from French-American hybrids. Upon his return to the United States, he began planting these in his Ritterwood, Maryland vineyard, Boordy Vineyard. A Baco Noir, released in 1945, has the distinction of being, we are told, "the first commercial varietal wine to be produced from the French hybrid grapes in the East." Wagner was so impressed with the quality of wines yielded by French-American hybrids that he could envision a change in American drinking habits, with dry wines overtaking sweet ones. He began to select and plant hybrids that had the best winemaking potential, discussing his findings with fellow winemakers and, through numerous writings and lectures, reaching to an ever-growing public. Hybrid cuttings from Wagner's nursery were soon appearing in vineyards throughout the East, with New Jersey wineries such as Alba, Amalthea, Amwell Valley and DelVista becoming loyal clients. (Only one New Jersey winery in 1988 did not grow French-American hybrids, and that was Sylvin Farms, which opted for *Vitis vinifera*.) A token of the esteem with which Wagner was regarded by fellow winemakers was the award he was given in 1981 by the American Society of Oenology, which praised his "dedication to the improvement of Eastern wines." It was a great understatement; more than improving wines, Wagner had catapulted them into national prominence.

French-American hybrids could yield pleasant wines, but even the most ardent advocate had to admit that superlative results could only be achieved using *Vitis vinifera* grapes—a seemingly impossible feat, for had it not been amply demonstrated that such grapes could not withstand the

harsh climatic conditions of the American Northeast? And then, of course, there was Phylloxera and the other pests. The New York State Agriculture and Research Station in Ithaca, New York, was not convinced and decided to undertake further investigation. In the spring of 1911, it obtained one hundred vinifera cuttings from the United States Department of Agriculture and the University of California; these were grafted onto labrusca roots and planted in soil rich in Phylloxera. To ward off mildew and other fungi, the vines were regularly sprayed with an anti-fungus solution, a procedure commonly followed in vineyards on both sides of the Atlantic. A novel solution was found to meet the problem of harsh winters: the vines were laid flat on the ground and covered with a thin layer of soil or straw. All the vines survived, prompting the station to conclude that Vitis vinifera could be grown "under a great diversity of conditions" and were, in fact, hardier than American vines. The station was cautiously optimistic about the future: "It is too early to reason from this short experiment that we are to grow varieties of European grapes commonly in the East, but the behavior of the vines under discussion seems to indicate that we may do so."

A decisive moment had been reached in American winemaking: "The culture of European grapes in the East gives the region essentially a new fruit. If any considerable degree of success attends their culture, wine making in Eastern America will be revolutionized, for the European grapes are far superior to the native sorts for this purpose." Interestingly, the station was not prepared to recommend the abandonment of hybrids; in fact, it thought that competition from *Vitis vinifera* would have the welcomed effect of encouraging the cultivation of *Vitis labrusca*: "The European grapes in the vineyards of eastern America ought to greatly increase the production of hybrid species and the American species of grapes." Unfortunately, Prohibition brought all of these promising developments to a close. Even after its repeal in 1933, eastern grape growers were reluctant to grow vinifera varieties, as America's love affair with sweet wines gave no signs of abetting. Furthermore, the scientific community was not encouraging: had not Philip Wagner, the foremost viticulturalist of this time, warned against planting *Vitis vinifera*?

But the pioneering work of the Ithaca Research Station was not forgotten. Not surprisingly, it was in New York State that the cultivation of *Vitis vinifera* on a commercial basis was first attempted. Charles Fournier, a one-time champagne maker at Veuve Cliquot in France, had come to the United States in 1934 to assume the post of production head at Gold Seal Vineyards in New York State. He must have been apprised of Wagner's warning,

for within two years he had replanted much of his vineyard with French-American hybrids. It was not long before Fournier realized that he would never be able to produce champagne of the quality of Veuve Cliquot using hybrids. He would have to plant *Vitis vinifera*, which he thought was possible, as blights such as Phylloxera and black rot had been brought under control. A formidable difficulty, however, remained: New York State's fierce winters. The technique of lying vines on the ground and covering them was deemed unfeasible in this climate. The answer came in 1953, when Dr. Konstantin Frank, a one-time Soviet viticulturalist, came to Gold Seal to join Fournier. Having grown *Vitis vinifera* in the cold climates of the Soviet Union, he was convinced that he could do the same in New York State. He set about testing rootstocks to see which could best resist the cold and decided against the readily available *Vitis labrusca* in favor of the less well-known *Vitis riparia*, a variety found in the American South. To minimize the impact of strong winds, he fell upon the novel idea of turning up the soil between the rows of vines. And rather than pruning redundant buds, he allowed some to remain as a replacement of those that had been destroyed by frost. The results were so encouraging that Frank decided in 1962 to leave Gold Seal and establish his own winery at Hammondsport, New York, which he named Vinifera Wine Cellars.

The import of Frank's achievements was not lost on eastern winemakers, who reasoned that if *Vitis vinifera* varieties could grow successfully in New York State, then they would thrive in regions farther south. A group of grape growers from Virginia set about organizing the Vinifera Wine Growers Association. In New Jersey, Sylvin Farms, as already noted, began growing viniferas, making it the first winery in the Garden State to do so. Owner Frank Salek, following Phillip Wagner's advice, had first planted French-American hybrids; then, realizing that they would have to be grafted onto cold-resistant stock, he decided to turn directly to *Vitis vinifera*. As he explained in a 1996 interview: "I decided a long time ago that you had to have good grapes to make good wine. When I couldn't find ones I liked I decided to grow my own." He proceeded to plant vinifera cuttings of cabernet franc, cabernet sauvignon, Gamay, Malbec, merlot, pinot noir and Chardonnay, which he obtained from California, and soon was producing wines of exceptional quality. Margaret Thomas, tasting Salek's wines in 1997, wrote: "I was blown away. The Chardonnay is distinguished and golden; Pinot Noir is redolent of fresh berries, the Cabernet Sauvignon has great flavor intensity and the Merlot is juicy and ripe." Salek, a one-time civil engineer, explained that he owed much of his success to his careful study of the soil's terrain: "Even the

slightest rise makes a difference. And in this location [Salek's vineyard in Germania] the steady southwest wind permits the vines to dry off in the summer so we have less of a problem with fungal diseases."

Sylvin Farms was founded in 1977. It took a decade for other wineries to follow its example and grow vinifera varieties. By the end of the 1980s, nearly every grape grower in New Jersey was cultivating at least some. Alba Vineyard grew cabernet sauvignon, cabernet franc, pinot noir, white riesling and sauvignon blanc; Tamuzza Vineyards grew pinot noir; Tewksbury Wine Cellars grew Gamay, pinot noir, Chardonnay, Gewurztraminer and white riesling; Tomasello Winery grew cabernet sauvignon and Chardonnay; and Amalthea Cellars grew cabernet sauvignon, pinot noir, Chardonnay, Gewurztraminer and riesling. Embracing vinifera was all the more remarkable given the opposition of such notable horticulturalists as Dr. Barbara Goulart of Rutgers University, who urged growers to plant French-American hybrids, calling them the "bread and butter" grapes. Matty Matarazzo, of Four Sisters Winery, agreed: "We should not try to copy wines from California and Europe but should strive to make our own unique wines. Our soils and climate are perfect for French hybrid varieties." But by 1988, even he was experimenting with Chardonnay, Gewurztraminer and riesling.

The 1980s had been a decade of trial and error in grape growing and winemaking, of experimental groupings, as Howard Goldberg reported. Plans had to be reconsidered, unrealistic goals modified or abandoned and expectations limited to what was possible, the last point lamely acknowledged by Michael Fisher of Amwell Valley, one of the wineries that would soon close its doors: "Our wines are better than many New York State wines and probably as good as a *vin ordinaire*." A modest ambition, indeed! Progress had certainly been made, but much still needed to be done. In the fifth decade since the repeal of Prohibition, elementary lessons had to be relearned, age-old certainties rediscovered. One is astonished to learn that as late as 1988 a vintner refused to vinify in oak because, he said, "it masks the true grape flavors." But such ignorance was exceptional. Most winemakers, and especially the newer ones, were willing to learn from past mistakes and expand their viticultural horizon, to learn from others, to adapt.

After visiting the Côtes du Rhône and Medoc regions of France in late 1986, Louis Caracciolo returned to New Jersey resolved to apply in his vineyard all he had learned. "We do not pick by machine," he told an interviewer.

*We go through three pickings in the French style. The first is when the picture perfect fruit comes in. Those grapes become the number one wine.*

An experimental test vine at Ventmiglia Vineyard.

*I believe, like the French, that wine is grown in the field. A machine is indiscriminate. When fruit is ready, pickers are trained what to pick. Wine makers are just custodians of a natural process. Using high tech goodies at our disposal is not an approach I favor.*

As the 1980s were ending, New Jersey's winemakers could face the future with confidence. An industry that had almost disappeared two decades earlier was alive and flourishing, with more new wineries opening their doors. California had shown that bigness was not necessarily better, technology not a cure all and corporations not always the best of guides, inciting New Jersey winemakers to strike out in a new direction: pursuing the foolhardy goal of wishing to produce wines of excellence. What type of men or women would be willing to engage in such a daunting venture? Stoutness of heart and intrepid risk-taking had to be abundantly present to embark on an undertaking in which the chance of failure was so high. For of the sixteen wineries existing in 1988, half had disappeared by 2000. If there is any truth in the adage that the blow that does not kill you makes you stronger, the surviving winemakers were titans of strength.

# *The Remarkable Years*

## (1990–2012)

On July 2, 1995, in a front-page article in the New Jersey edition of the *New York Times* entitled "Peel Me a Grape," Howard Goldberg, whom we have already encountered, reported:

> *Once so tiny, it scarcely deserves the name "industry," the New Jersey wine making business is coming of age. These eight producers* [visited by Goldberg] *are turning out serious wine, from old vines and new, with old techniques and new, from well-known premium grapes like Chardonnay and Riesling and from French American hybrids like Seyval Blanc and Maréchal Foch.*

The subheading read: "Across the state, a new breed of growers turn out wines to be proud of, trouble is, hardly anyone heard of them." Fifteen years later, there was hardly a serious wine drinker in the Garden State and its region who had not heard of and enjoyed its wines.

Bart Jackson, a former president of the American Wine Society, in his excellent *Garden State Wineries Guide*, recounts having tasted Alba Vineyard's 1985 Cabernet Sauvignon, made by Rudy Marchesi more than twenty years after it had been bottled, "and it still was a magnificent wine, showing its age now but a hint of black cherry fruit remained as well as complexity few had dreamed was possible when this wine was produced." He also uncorked a 1987 Riesling from Kings Road Vineyard twenty-three years after it had been bottled and found it "glorious." But could New Jersey wines stand up

against those of France? Jackson decided to conduct a blind tasting, putting up five Chardonnays and five cabernet sauvignons against an equal number produced in Burgundy and Bordeaux. Writes Jackson: "The results were astonishing. Both in the case of Chardonnay and the Cabernet wines the Jersey wines scored higher than their French counterparts." California wines were evidently not the only ones able to defeat those of France—although the New Jersey event, not having been witnessed by a *Time* reporter, had no national impact.

More blind tastings were organized by Louis Caracciolo in 2007 and 2008, pitting Amalthea's cabernet sauvignon, merlot and Chardonnay against such world-renowned wines as a 2001 Mouton Rothschild Cabernet Sauvignon, a 2004 Cheval Blanc Grand Cru Classé, a 2005 Latour Puligny-Montrachet Chardonnay, a 2003 Silver Oak Cabernet Sauvignon and a 2006 Cakebread Cellars Chardonnay. The jury consisted of over fifty certified wine tasters, wine educators and professional sommeliers. George Taber, a participant, quipped to the *Star Ledger*'s premier wine writer, T.J. Foderaro: "At first it sounded outrageous. It's like putting a kid from Pop Warner into an NFL game." Using the Dionysian Society's twenty-point system, Amalthea garnered top honors—an extraordinary achievement, indeed! Taber could not help recalling the event that, three decades earlier, had launched his wine writing career: "As in Paris…if a wine can be picked out of a line up of world class wines then, by definition, it is a world class wine."

With these tastings, the myth that New Jersey could not produce exceptional wines was laid to rest. In the face of popular ignorance—and until recently, of governmental indifference if not hostility—a handful of intrepid winemakers had succeeded in producing world-class wines. An activity previously practiced by farmers intent on making passable wine meant for their own consumption and a few commercial wineries producing potent but otherwise nondescript brews had evolved into a burgeoning industry increasingly known for its exceptional wines—the number of wineries climbing to twenty-two in 2003, thirty-seven in 2008 and an astonishing fifty-four in 2011. The increase in wine production has been equally impressive, rising from 190,000 gallons in 2000 to 282,000 in 2008 and nearly 1 million gallons in 2011.

The fearful voyage of New Jersey wine is done, to paraphrase Walt Whitman. Exceptional wines are being made in the Garden State. But as has often been the case with New Jersey achievements, the news remains a best-kept secret. Labels unfortunately have power; the gaze of the wine drinker invariably falls on provenance and thereupon comes under the sway of

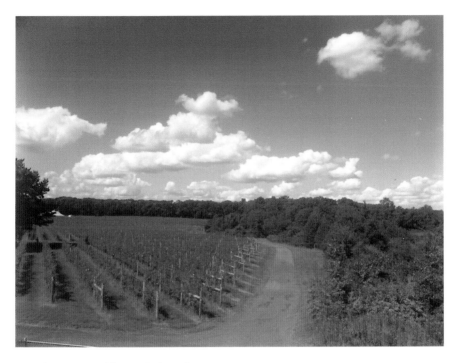

View from Laurita Vineyard's front door.

Laurita's spacious interior...

...and current offerings.

Laurita's chateau...

...and its solar power.

Welcome to Silver Decoy.

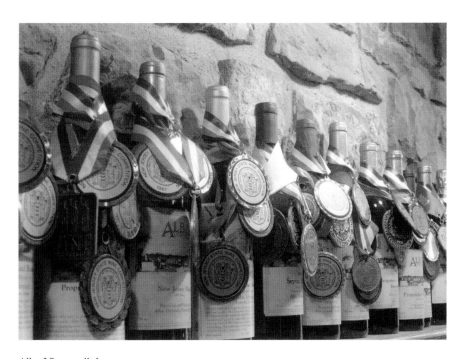

Alba Vineyard's best.

From Silver Decoy's front patio.

Silver Decoy's Chardonnay.

*Above*: Where Lord Sterling's estate once stood.

*Left*: Vintage award at Alba Vineyard.

Alba Vineyard. Stored in oak.

*Below*: Alba's front door.

Alba Vineyard. A happy soul.

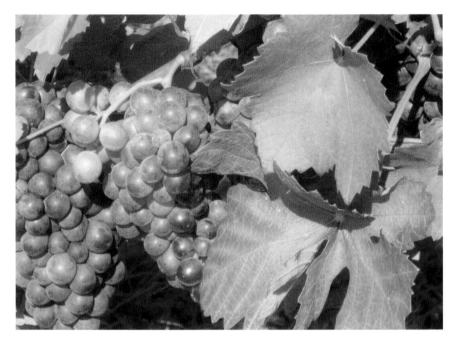

Lucious Alba.

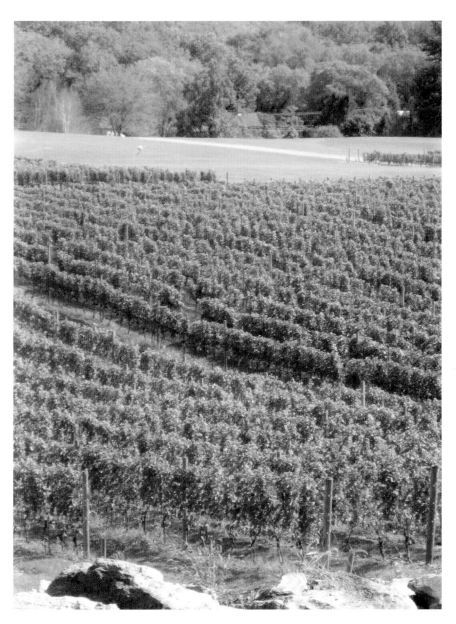

Alba's vista.

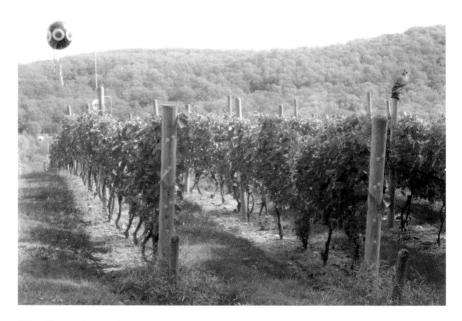

Alba Vineyard. A rolling hill...

...and the crushing station.

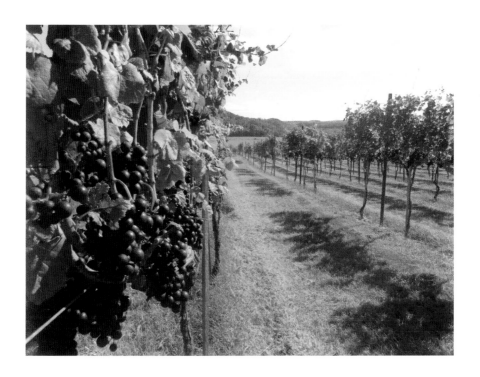

*Above*: "Organic" vine at Villa Milagro.

*Left*: Unionville Vineyard. The end of the line.

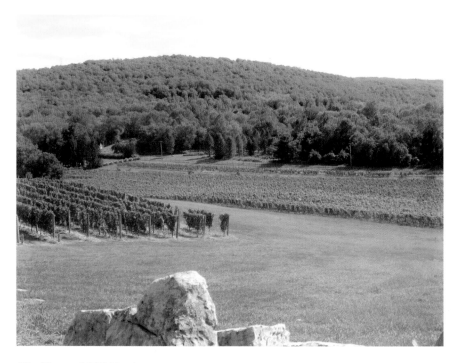

Alba Vineyard. Hillside vines.

Unionville Vineyards. End of the season.

Unionville.

Silver Decoy. Tools of the trade.

Old York Vineyard. A happy customer.

*Left*: Alba Vineyard. A row of Sangiovese…

*Below*: …and a scarecrow owl.

Sunset at Almathea Vineyard.

geographic myths. If New Jersey wines are to receive the recognition they so richly deserve, these myths will have to change, forging a new identity for the state. Associating it with Bordeaux would have the advantage of bringing to mind the notion of winemaking excellence, thus giving new life to Edward Antill and William Alexander's eighteenth-century dream of reproducing the wines of the crescent city.

The last two decades have witnessed a veritable transformation of New Jersey vineyards. The cultivation of French-American hybrids has waned, while native American vines such as Catawba, Delaware, Niagara, Isabella and Concord, at one time ubiquitous, have virtually disappeared. At the same time, *Vitis vinifera* varieties are being widely planted, as the following breakdown culled from Jackson's *Guide* makes clear:

> *The 4 JG Vineyards: Chardonnay and Cabernet Franc. Alba Vineyard: Cabernet Sauvignon, Chardonnay, Riesling and Pinot Noir. Amalthea Cellars: Cabernet Franc, Cabernet Sauvignon, Chardonnay, Merlot, Riesling. Auburn Road Vineyard and Winery: Merlot, Chardonnay.*

*Bellview Winery: Syrah, Cabernet Franc. Brook Hollow Winery: Cabernet Sauvignon, Gewurztraminer. Cape May Winery and Vineyard: Cabernet Sauvignon, Syrah, Chardonnay, Cabernet Franc, Merlot, Riesling. Cava Winery and Vineyard: Cabernet Franc. Cedarvale Winery and Vineyard: Cabernet Franc, Chardonnay, Merlot, Syrah. Coda Rossa Winery: Cabernet Franc, Cabernet Sauvignon, Merlot, and Syrah. Cream Ridge Winery: Cabernet Sauvignon, Cabernet Franc, Pinot Gris and Riesling. Di Bella Winery: Cabernet Franc, Cabernet Sauvignon, Chardonnay, Merlot. Di Matteo Vineyard: Merlot, Syrah. Hawk Haven Vineyard and Winery: Merlot, Cabernet Sauvignon, Cabernet Franc, Syrah and Riesling. Heritage Vineyards: Cabernet Franc, Merlot, Chardonnay, Syrah. Hopewell Valley Vineyards: Chardonnay, Cabernet Sauvignon, Merlot, and Pinot Noir. Laureta Winery: Cabernet Franc, Cabernet Sauvignon, Merlot, Pinot Gris. Natali Vineyards: Cabernet Sauvignon. Old York Cellars: Syrah, Merlot, Cabernet Sauvignon, Chardonnay, Riesling. Plagido's Winery: Cabernet Franc, Chardonnay, Merlot, Cabernet Sauvignon. Renault Winery: Cabernet Franc, Cabernet Sauvignon, Chardonnay, Gewürztraminer, Merlot, Riesling and Sauvignon Blanc. Sharrott Winery: Chardonnay, Riesling, Cabernet Franc, Syrah. Silver Decoy Winery: Cabernet Franc, Chardonnay, Merlot, Riesling, and Syrah. Swansea Vineyards: Chardonnay. Sylvin Farms Winery: Sauvignon Blanc, Cabernet Franc, Cabernet Sauvignon, Pinot Noir, Rkatsiteli, Semillion, Merlot and Chardonnay. Terhune Orchards: Chardonnay, Merlot Riesling, Sauvignon Blanc, Cabernet Franc. Tomasello Winery: Cabernet Sauvignon, Riesling, Chardonnay. Union Vineyards: Chardonnay, Pinot Noir, Cabernet Sauvignon, Riesling, Syrah. Valenzano Winery: Cabernet Sauvignon, Cabernet Franc, Chardonnay, Merlot. Ventimiglia Vineyard: Cabernet Franc, Syrah. Villa Milagro Vineyards: Chardonnay, Cabernet Franc, Cabernet Sauvignon and Syrah. Wagonhouse Winery: Cabernet Sauvignon, Merlot, Chardonnay and Pinot Gris.*

The rise of New Jersey wines has had a telling effect on the state's gustatory activities—not surprising as fine wines and fine cuisine are gastronomical allies, each enhancing the other. Such a relation was not considered or even suspected in a state not known for fine eating. As late as 1997, Marguerite Thomas, in her *Wineries of the Eastern States*, observed: "Other than this Renault duo [the winery's Garden Café and Gourmet Restaurant] there are virtually no interesting restaurants in Southern New Jersey until you get to the charming inns and eateries of Cape May." I am not aware of

the presence of "interesting restaurants" in the northern part of the state either, at least then. As to "charming inns and eateries" of Cape May, these must not be confused with two- or three-star *Michelin Guide* restaurants. Such establishments, although possibly without Michelin's ranking, can now be readily found throughout New Jersey, serving world-class wines often produced in nearby wineries.

With its innumerable orchards and berry fields, New Jersey produces an extraordinary variety of wines derived from fruits other than grapes: apples, peaches, pears, plums, cherries, blueberries, blackberries, strawberries, raspberries and cranberries. Most recently, the Balic Winery introduced a wine made from pomegranates whose juice is reputed to destroy breast cancer cells and lower levels of cholesterol. (Could this also be the case with pomegranate wine?) The Cream Ridge Winery garnered six Governor's Cups for its cherry, plum and cranberry wines. The renown of Tomasallo's fruit wines has spread beyond New Jersey's borders to nineteen states, as well as Japan, Taiwan, South Korea, China and Singapore. Especially appreciated is Renault's blueberry champagne, still a national favorite.

In considering New Jersey wines, one cannot fail to note Europe's centripetal pull, particularly that of France and Italy. Louis Caracciolo, a frequent visitor to both countries, was struck by the continent's diverse winemaking and culinary traditions, which, he thought, should serve as a model to the United States. "Regional differences in the United States should be recognized and encouraged as they are in Western Europe," he remarked in an interview. "Different regions in France have different styles and types of wine, thus adding to the pleasure of travelling from one area to another." Jim Williams of Delvista was likewise inspired by the old continent, explaining that he and his wife, Jeanette, wanted "to produce classic European-style table wines that are dry, well balanced and complement various foods." And Amwell Valley's Michael Fisher bluntly declared that his aim was to produce wines "in the classic European tradition."

A winery's very appearance may evoke Gallic or Italian souvenirs. Jennifer Rignani, exploring the Lower Cape May region, found it to be "somewhat similar to the Bordeaux region of France, which lays between the Atlantic and the Lower Gironde River especially the area known as the Medoc." The Italian influence is especially evident in the design of interiors such as that of Cava Winery. "Beneath the winery's sturdy beams," writes Bart Jackson, "owners Anthony and Deneah Riccio had drenched their tasting room with atmosphere Italiane. Chianti-red tablecloths, the warmly paneled walls laden with intriguing art, all reflect the Mediterranean feel of Cava's

wines." Auburn Road's tasting room—given the Italian name *Enoteca*, Italian for wine cellar—resembles a European café, while that of Coda Rossa contains the mockup of a typical Italian storefront and fountain. With its handsome outdoor mural—painted by the renowned Puerto Rican/French painter Samuel Quinones—any visitor to Amalthea Cellars could mistake it for a charming Burgundian chalet. Etched in our mind is the multi-arched entranceway of Hawk Haven Vineyard and, worthy of a palazzo, Valenzano's meticulously tended lawn and gardens.

In one respect, New Jersey wineries are markedly different from European ones: the role they play as recreational centers. Brook Hollow has erected a museum of farm tools and provides picnic facilities on its broad lawns, as well as a two-hundred-seat tent for special events. Auburn Road invites visitors to "relax with a glass of wine, artisan cheeses, or some homemade gelato. Spend an afternoon enjoying the sunshine among the vines in the Enoteca courtyard. Hang out for a great live performance that evening." Bellview offers cooking demonstrations, wine-tasting courses, a jazz festival and a seafood festival. A farm adjacent to the Heritage Vineyards encourages

Cava Vineyards' coat of arms.

a visitor to pick apples, pumpkins and pears. Hopewell provides courses on winemaking and organizes music nights. Laurita makes available equestrian facilities and a healing and massage spa. Terhune Orchards sponsors a puppet theater, a kite-flying day and courses in canning and preserving. Amalthea boasts a gourmet restaurant, which doubles as a meeting place modeled after the Green Dragon Tavern, where the American Revolution was planned. Visiting a New Jersey winery is much more than discovering fine wines!

With the exception of such large-scale operations as Renault and Tomasello, most of New Jersey's wineries are small in size, with annual production rarely exceeding twenty thousand gallons, thereby allowing winemaking to be conducted as a craft. This is not an afterthought but the stated goal of numerous wineries: "Striving to create hand crafted wines with excellent structures, flavors and complexity, we express the distinct varietal characteristics of each type of grape in the vineyard." (Swansea Vineyards); "Committed to honest craftsmanship...we produce wines that constantly win honors in national and international competitions." (Alba Vineyard); "We take pride in crafting fine estate wines exclusively from quality grapes cultivated in our 25-acre vineyard." (Bellview Winery). New Jersey wineries are increasingly committed to procedures and materials that ensure long-term sustainability. Turdo and Sharrott rely on solar power and employ organic fertilizers. Villa Milagro insists on using locally produced manure and will not plant any vines until the soil has been detoxified. Wagonhouse minimizes the use of sprays to control fungi and insects.

However pronounced the changes in the operation of wineries have been, some aspects of winemaking have remained remarkably constant. Harvests continue to be festive events, with every family member participating and neighbors and friends joining in. Bottles are uncorked, and suddenly two platters appear, one covered with steaming pasta and the other with the richest tomato sauce. (I can never forget Marie Caracciolo's exquisite pasta and tomato sauce.) The season of celebrations continues with Oktoberfest: pick your own fruits and vegetables, vineyard tours, cheese and wine-tasting parties, concerts for every musical taste and, for children, hayrides and games of skills. A ritual thousands of years old is reenacted: human beings giving thanks for the earth's bounty. Another cycle in nature's never-ceasing drama of eternal regeneration is nearing completion: planting and pruning, harvesting, pressing and vinifying—activities so ordinary and yet so quintessential, holding up the promise, as with poetry, of deliverance from

Alba Vineyards. Young picnickers.

Unionville Vineyards. A speech.

*Above*: Villa Milagro. The entire building.

*Left*: Villa Milagro. A transaction.

the prosaic and mundane. A sign in Cedarvale Winery proclaims, "Wine is bottled poetry." It could not have been better said.

New Jersey's distinct approach to viti-viniculture becomes apparent when contrasted to that of California, described so succinctly by Thomas Pinney in *A History of Wine in America*:

> *Presses of every size and principal of design: pneumatic drum presses, electrically powered hydraulic basket presses, progressive-draining presses, self cleaning bladder presses, jacketed presses for temperature control, closed presses to prevent oxidation, open membrane presses, tank presses.*

The manipulation is far from over. There is micro oxygenation in which oxygen is introduced in wine kept in steel tanks; induced malolactic fermentation, which softens the malic acid; and reversed osmosis to increase the alcoholic level. A troubling thought begs attention: is this winemaking or technological prestidigitation? Two vitally important elements having been eliminated: the creative input of the winemaker and the soil's distinct attributes, what the French call *le terroir*. The wines that result must necessarily lack the sharp edge of personality so clearly present in New Jersey wines. If wines were but a pleasant beverage, California's high-tech approach would be perfectly appropriate. But wine, we insist, is not such a beverage, a mere oral distraction, but has higher aspirations. (Admittedly, not all California winemakers ignore the dictates of experience and *terroir*, but they are a distinct minority.)

New Jersey was to experience another wave of winery failures in the late 1980s and early 1990s, due in large measure to adverse environmental conditions, for the seven wineries that disappeared were located in the northern and north-central parts of the state, where winters tend to be harsh. Owner Daniel Vernon of Tewksbury blamed the winery's demise on geography and the fact that he had planted vinifera varieties. "In the northern part of New Jersey," he told a *New York Times* reporter, "it doesn't work to grow vinifera." A similar complaint could have been made by Jim Williams, another owner of a failed winery, who likewise had planted viniferas. And yet wineries located in the same general area such as Alba and Four Sisters, each with vinifera under cultivation, managed to survive, a sign that viticultural policies had, at the very least, contributed to the failures. Such was probably the cause of the demise of Amwell Valley, owned by Dr. Michael Fisher and his wife, Elsa, who had bought the twenty-acre farm after "Mike had read an article in *Scientific American* on grape growing and wine making and decided he would like to try growing grapes as a hobby."

Picnic at Alba's jazz concert.

Not the ideal inception for a career in winemaking! As in the early 1980s, individuals continued to be drawn to grape growing/winemaking without possessing the required knowledge and experience.

The 1990s were prosperous years, with Americans increasingly turning to the consumption of fine wines. An extraordinary disclosure made on the popular news program *60 Minutes* in November 1991 riveted the nation's attention to the health benefits of wine drinking. Americans learned that although they ate less fatty food than the inhabitants of Gascogne in southwest France, the French were less susceptible to heart disease because they drank red wine with their meals. Dubbed "the French paradox," the news precipitated a wine-buying craze throughout the nation. An avalanche of wine-related events was unleashed: wine courses, wine clubs, wine television programs, the publication of countless wine magazines and books. Wineries previously frequented by wine-drinking

Alba Vineyard.
Extracurricular activities.

aficionados suddenly became popular tourist attractions. Again, there was a surge in the number of wineries, with fifteen new establishments opening their doors by 2000.

The increase in wine-related activities is all the more remarkable given the rise in the late 1980s of prohibitionist sentiment, avowedly on medical grounds. After a vigorous campaign conducted by conservatives, the U.S. Congress, in 1988, passed the Alcoholic Beverage Labeling Act, which mandated that the following message appear on every bottle of wine: "Government Warning: according to the Surgeon General, women should not drink alcoholic beverages during pregnancy because of the rise of birth defects. Consumption of alcoholic beverages impairs your ability to drive a car or operate machinery and may cause health problems." Two facts were conveniently ignored—although consuming more wine then their American sisters, Frenchwomen are not more likely to give birth to babies with health problems, and drivers are not more likely to die

on French highways than American ones—leading one to suspect the lurking presence of a moral agenda.

As the first decade of the twenty-first century was ending, the prospects of New Jersey wines could not have been brighter. A photograph of Bill and Penny Heritage, owners of the winery bearing their name, which appears in Rignani's *New Jersey Wineries*, captures the tenor of New Jersey winemaking in those years. The two are standing in their vineyards, the bare vines evidence that the grapes had been picked, the smile a sign that the harvest was bountiful. They may have an additional cause for contentment, having learned that they are the recipients of *South Jersey* magazine's "Best of the Best" award for estate-grown wines. But a larger reason cannot be ruled out: the promising prospects of winemaking in the Garden State. An industry nearly extinct two decades earlier has, phoenix-like, risen from its ashes. More reasons to smile!

With fifty-four bonded wineries producing one million gallons of wine a year, New Jersey in 2010 had become the sixth-largest producer in the United States. New Jersyites were flocking to the state's wineries, attendance soaring to sixty thousand, with thousands more attending the annual food and wine festivals. Louis Caracciolo, the long-standing president of the New Jersey Wine Growers Association, had reason to be optimistic, telling a *Star Ledger* reporter:

> *There are people here in New Jersey who have travelled the world tasting some of the very best wines. As they start looking closer to home, maybe to organize a "staycation," I think they are impressed by the quality and variety of the wines we have right here. It reminds me of what Napa once was way back. Those who have never visited one of our wineries will be surprised to find just how welcoming and exciting they are, visitors being encouraged to come down to the cellar and taste wine right out of the barrel.*

No one was particularly surprised when the *Courier-Post* entitled a front-page article: "New Jersey: The Wine State."

A defining moment in the history of New Jersey wine occurred on March 27, 2010, in a symposium organized by the Outer Coastal Plain Vineyard Association in collaboration with Rutgers University and with support from the Garden State Wine Growers Association. It was held in Bridgetown on the theme of "Bordeaux: An Old World Terroir with Lessons for New Jersey." The following explanation was provided:

*Leading authorities from Bordeaux and the United States will examine those components of terroir which matter most in quality grape and wine production as well as the value of technology in controlling the wine making process. Specifically those components of terroir that contribute most to the greatness of Bordeaux wine will be emphasized in an effort to optimize viticulture in New Jersey.*

Five lectures were in the program: 1) "Optimizing New Jersey Viticulture for Quality Wine Production," by Dr. Lawrence Coia; 2) "Terroir of Bordeaux," by Dr. Kees van Leeuwen; 3) "Similarities and Differences in the Regional Climate and Soil Characteristics of New Jersey and Bordeaux," by Dr. Denyse Lemaire; 4) "Climate Component of Terroir: Structure and Suitability for Sustainable Wine Production," by Dr. Gregory Jones; and 5) "Crafting Bordeaux-Style Wines in New Jersey," by Dr. Catharine Peyrot des Gachons. The conclusion reached by these experts was that the geology and climate of New Jersey were similar to those of Bordeaux, suggesting a comparable resemblance in winemaking possibilities. The implication could not have been more tantalizing. New Jersey had the potential to produce first-growth wines. All of us in the audience knew that a historic threshold had been reached.

Then, eight months later, catastrophe. New Jersey wineries were confronted by a devastating court ruling. On December 17, 2010, the U.S. Court of Appeals for the Third Circuit declared that, as "all out of state wine, but not all instate wine, must pass through an instate wholesaler and retailer before reaching consumers," New Jersey was in violation of the 2005 U.S. Supreme Court's *Granholm v. Heald* decision, which held that the states may not discriminate between in-state and out-of-state wineries. Finding that there was no legitimate basis for this unequal treatment, the court ruled that the privileges that allowed farm winery licensees to sell directly to retailers or consumers were in violation of the law. It sent the case back to a lower court with two options: grant out-of-state wineries the right to sell to New Jersey customers or prohibit all such sales, those of New Jersey included. Should the latter option be adopted, the impact on New Jersey wineries would be catastrophic.

Scott Donnini of Auburn Road Vineyards and Winery was speaking for all winery owners when he warned: "If we're forced into the three tier system—1) Suppliers sell to wholesalers, 2) Wholesalers sell to retailers and 3) Retailers sell to consumers—you're going to put 90 to 95 percent of the Jersey wineries immediately out of business, and the rest will follow closely."

Realizing that the very survival of the state's wine industry was at stake, the Garden State Wine Growers Association took the extraordinary action of retaining Jim Florio, former governor of New Jersey, to lobby on its behalf. A bill (S3172) was introduced in the state senate that would allow wineries in and outside New Jersey to sell directly to individual clients, thereby bypassing distributors and liquor stores. Wineries would also be permitted to open up eighteen retail outlets. To no one's surprise, distributors and retailers fiercely opposed the bill. The president of the New Jersey Liquor Store Alliance declared it a threat to liquor stores and warned that its passage would encourage underage drinking. Opposed by a coalition of Republicans with links to distributors and northern Democrats fearful of antagonizing the many liquor storeowners in the region, the bill would have certainly gone down in defeat had it not been for the valiant efforts of the state's most powerful Democrat, senate president Stephen Sweeney, who declared, "The limited access people have suffocated an industry that has enormous potential for growth. New Jersey's wine industry can grow by leaps and bounds if we act to change our current flawed policies."

A decision had to be made by March 21, 2012, as required by the Court of Appeals, after which date wineries would be barred from selling wine to the public. However, as the legislative session was ending on January 9, the bill would have to pass both the senate and assembly before the end of that day, a daunting feat as neither chamber had scheduled a vote on the bill, which was still languishing in committee. Ignoring the objections of fellow Democrats, Sweeney took S3172 out of committee and brought it to the floor of the senate, which passed it twenty-three to thirteen. (One suspects the discreet influence of Governor Florio.) With only hours remaining, Sweeney learned that the assembly committee charged with reviewing the bill, under pressure from the New Jersey Restaurant Owners Association, had voted to reject it along party lines. Sweeney now took the unusual step of ordering the senate into recess and walking over to the assembly, where he announced that if that body did not reverse the committee's action, the senate would not act on four of Governor Christie's appointments. Moments later, an emissary from the governor arrived instructing the Republicans in the assembly to approve the bill, which it did. On March 17, Governor Christie signed it into law. What was certainly the most dramatic moment in the history of New Jersey winemaking could not have had a more felicitous outcome thanks to Governors Florio and Christie and, above all, Senator Sweeney!

# The Remarkable Years

New Jersey wineries have continued to hold their own against the best of France and the West Coast—the last such encounter occurring in Princeton on June 8, 2012, in a replay of the Judgment of Paris. What follows is an in-depth interview with Julia V. Anderson, assistant to contest coordinator Karl Storchmann, who participated in the event:

*Q. How did the Judgment at Princeton come about?*
*A. The idea was George Taber's, who, in 1976, was a reporter for* Time *magazine and is the only journalist to have witnessed the 1976 Judgment of Paris. He later wrote a book on the event judgment and, a wine fanatic, wanted to renew the experiment. He saw the American Association of Wine Economist's annual conference in Princeton, New Jersey, as an opportunity to put New Jersey wines, which have been growing in quality and reputation this past decade, to the test.*
*Q. What was the scene of the tasting?*
*A. In the morning of Friday, June 8, George Taber, Karl Storchmann and three researchers, including myself, met in the pale blue tearoom of Princeton University's Prospect House, an Italianate Victorian mansion overlooking an elaborate flower garden in full bloom. The room was bright that morning, and the sun was hitting the ninety empty wine glasses orderly disposed on four white-clothed round tables through the tall-pane windows. George Taber's elegant powder blue suit was like the materialization of the spring cheerfulness that was in the air that morning. The tasting would be in two parts: first the whites and later the reds. The French wines selected were from the same producers as in 1976, including names such as Chateau Mouton-Rothschild and Haut Brion, priced up to $650 a bottle. The New Jersey wines, priced up to $50 a bottle, had been submitted to an informal panel of judges (which included Professor Storchmann), who had then selected the wines for the competition. These judges were not eligible to taste wines at the final competition.*
*Mr. Taber and Professor Storchmann, excited to the point of nervousness, gave strict instructions: pour wine from each of the ten numbered paper-bagged bottles into their assigned, lettered glasses. As we poured, we retained a high level of concentration; we had been warned: a mistake in the pouring would nullify the results of the tasting. So we poured, carefully, not without some spilling on the immaculate tablecloths. The ninety glasses filled, our noses saturated with fragrant alcoholic vapors and our minds shaken with excitement,*

*we opened the doors of the tasting room and let the nine judges enter.
Three francophone judges cheerfully sat at the same table, followed by
some of their more solemn American counterparts. When all of the
nine judges were finally seated (three Frenchman, one Belgian and five
Americans), the doors were closed again, and we left the room for the
gardens. When we reentered the room, some thirty minutes later, the
excitement had reached its peak as the judges, after having submitted
their grades, were now playing at guessing the provenance of each wine.
And so the judges left the room, and we poured again, this time red
wines. We stayed a few minutes in the room after the beginning of
the second judgment. As a Frenchwoman, my ear instinctively filters
through noise to listen to French when it is spoken. I remember hearing
a French judge proclaiming with extreme confidence that this wine
was Bordeaux and that one not. While the francophone judges tasted
playfully, the American judges, very serious, remained mostly silent and
would communicate mostly in nods and severe looks. After another thirty
minutes, the judges left. We diligently finished any leftover Mouton-
Rothschild and went to hear the awaited results.*

*Q. Could you talk about the results?*

*A. The results of the tasting were surprising. Although, the winner
in each category was a French wine (Clos de Mouches for the whites
and Mouton-Rothschild for the reds), New Jersey wines come very
close behind. Three of the top four whites were from New Jersey. The
best New Jersey red was ranked place three—an amazing result given
that the prices for New Jersey average at only 5 percent of the top
French wines. A statistical evaluation of the tasting was conducted by
Princeton professor Richard Quandt. He showed that the rank order of
the wines was mostly insignificant; that is, if the wine judges repeated
the tasting, the results would most likely be different. Therefore, from
a statistical viewpoint, most wines were undistinguishable. Only the
best white and the lowest-ranked red were significantly different from
the other wines. The tasting therefore showed what it was intended to
show: that wine is mostly a matter of taste. Wine economists have
closely studied the matter of wine expertise and have concluded that
it is bullshit. In 2007, Professor Richard Quandt analyzed the wine
market and determined "the wine trade is intrinsically bullshit-prone
and therefore attracts bullshit artists." In 1976, after the identity of
the wines was revealed, Odette Kahn, editor of La Revue Du Vin
De France, demanded her scorecard back. Apparently, she was not*

*happy with having rated American wines number one and two. At the Princeton blind tasting, the French judges preferred New Jersey red wines over their counterparts from Bordeaux but, after disclosure, did not complain.*

# The End of the Beginning

It was in the fall of 1986, in the course of a dinner in La Mule du Pape, the renowned restaurant in Châteauneuf-du-Pape, that the Third Wave was conceived as the last phase in the history of winemaking and as a guideline for progressive winemakers. Present were Amalthea Cellar's Louis Caracciolo, on a scientific mission to France; M. Jean Bécamel, world traveler and wine connoisseur; and myself, translator and facilitator. We had just completed the first course, a perfectly prepared omelette aux cêpes, washed down with an excellent Gigondas, when Louis asked me to translate the content of a leaflet that had somehow found its way to our table. It consisted of the following excerpt of Alphonse Daudet's classic short story "The Pope's Mule":

> Every Sunday, upon completing vespers, the worthy man would honor the mule with a visit and when so occupied, the mule near him, his cardinals stretched out all about at the feet of the vines, he would open a flask of wine form his cellar—this beautiful ruby colored wine which since then is known as Châteauneuf-du-Pape, which he would taste in small sips while casting tender graces at his vineyard. Then the flask empty, the day beginning to ebb, he would happily head back to the city followed by his entire chapter. Passing over the Pont d'Avignon, stirred by the sound and sight of drums and Provençal dances, the mule would take little hops while he would mark the beat with his walking stick which greatly shocked the cardinals but elicited from everyone else exclamations of: "What a good prince! What

*a worthy Pope!" "A human Pope," I observed. "More than human," M.*
*Bécamel corrected, "wise, judging from his keen appreciation of fine wine."*

"Unlike the cardinals who did not or at least pretended not to!" interjected Louis. "The story reminds me of those happy times when we would gather to taste my grandfather Emilio's wine. He came to New Jersey from Naples, bringing with him the knowledge of winemaking, which he had learned from his father. As a thirteen-year-old boy, I became enamored of winemaking, couldn't wait for the pressing to begin. I was hooked and have remained so!" He paused and then raised his glass: "To my grandfather Emilio, a man both human and wise, who taught me everything I know about archaic winemaking!" He emptied his glass, M. Bécamel and I doing likewise.

"But I am sure he didn't teach about ozone," M. Bécamel said with a mischievous smile. "How do you explain your interest in this high-technology gas? I would think that as a traditionalist, you would be its foe."

Louis took another sip from his refilled glass before responding. "I do not oppose technology as long as it does not threaten the earth's fragile biosphere, which is not the case with ozone. Spray a surface and all bacteria disappear. I don't see anything wrong with that unless you are against washing your hands!" We all laughed. "And as far as being a traditionalist," he continued, "that is hardly how I view myself, although there are traditions I strongly uphold."

I was about to ask M. Bécamel whether he thought that French winemakers could be induced to employ ozone when the waiter arrived at our table, bringing a platter of aubergines à la Provençale—thinly sliced eggplant seared in strongly aromatic French olive oil, blanketed with a rich tomato and onion sauce. M. Bécamel exchanged a few words with the waiter, who returned with a bottle of Châteauneuf-du-Pape, a 1979 Saint Michel.

"I thought you might enjoy this particular wine," our host explained, "which may have come from the very vineyard that produced the wine that so enchanted our 'worthy Pope.'" Those last words led me to examine the wine's color, which was indeed ruby red, as Daudet had written. What we imbibed was truly a masterpiece: all the elements in perfect balance, tannin and acidity reduced to their essential core, flavors and aromas imparting the subtlest sensations to the oral and olfactory senses. If palettes can be bedazzled, ours were—three loquacious men rendered speechless, their thoughts suspended in wonder.

Louis subsequently revealed that it was while sipping the Saint Michel that the idea of wine's three-part history arose in his mind: the First Wave emerging

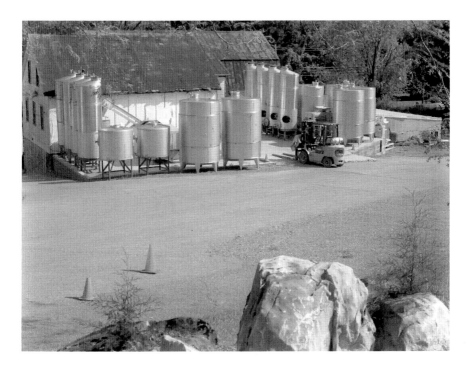

Alba from the fields.

during the agrarian revolution in the Neolithic period and continuing until the mid-nineteenth century; the Second Wave beginning in the 1850s with Pasteur's pioneering research in yeast fermentation and reaching its apex in the mid-twentieth century in Napa Valley; the Third Wave, also called the Archaic Revival, arising in the closing decades of the twentieth century. Following our visit to Côtes du Rhône, Louis and I headed for Bordeaux and St. Emilion, where meetings were arranged with such celebrated winemakers as Michel Rolland, Jean Claude Aubert and Paul Pontalllier, the last agreeing to do a test of ozone at Château Margaux (the same agreement was later obtained from M. Bernard Gay, technical director at the Listel Winery in Languedoc). Within a year, a team of engineers led by William Caracciolo, Louis's brother, had conducted successful tests at Margaux and Listel—to my knowledge the first time that American technological know-how had managed to penetrate a French winery—not a mean achievement for two denizens of Camden county, New Jersey.

If there was a lesson that Louis drew from his many visits to the Bordeaux and Côtes du Rhône regions—more followed in subsequent years—it was that

winemaking is a natural process: planting, harvesting, crushing and vinifying requiring no chemical or complex mechanical intervention, a reaffirmation of the eighteenth century's belief in natural ways. Rather than striving to dominate nature—the way of the Second Wave—the winemaker views himself as a partner of nature, coaxing rather than coercing. Louis employs the metaphor of "dancing." One has entered a craft-oriented, postindustrial world in which quality ranks higher than quantity, the hand is more valued than any mechanical device and vision and insight are no less fructuous than knowledge and rational thought. No longer considered a commodity, wine has become a catalyzing agent of physical and emotional well-being, a pathway to self-realization and the expansion of consciousness. The size of the customer base having ceased to dominate the vintner's concerns, competitive impulses will be replaced by cooperative ones, a communal spirit thereby emerging wherein mutually advantageous endeavors can be successfully pursued. A salient feature of the Third Wave is its inclusiveness. Second Wave technology is welcomed, provided, of course, that it does not subvert the natural process. Therefore, devices such as mechanical crushers, temperature gauges, pumps and assembly lines have a legitimate place in winemaking. As for traditional notions so central in the First Wave, these evoke a tempered response, being neither categorically rejected nor blindly embraced. If folklore, almanacs and other labors of the imagination are dismissed, practices that have met the test of time—a particular approach to pruning or harvesting, a half-forgotten trellising technique, a way to ensure fermentation—are welcomed. More than a series of winemaking techniques, the Third Wave invokes a radical transformation in man's relation to the environment. Committed to the principle of sustainability—that is, adopting practices that are ecologically sound—the Third Wave favors the use of renewable sources of energy such as biodiesel and of organic and not chemically manufactured fertilizers and insecticides. Such profound changes will necessarily bring about a change in perceptions and perspectives, taking us into realms beyond the ego, now viewed as just another superstition.

Twenty-five years have passed since that memorable dinner in La Mule du Pape when the idea of the Third Wave was born. If numbers are a measure of success, the Third Wave has been immensely successful. For I know of no new winemaker in the United States, certainly east of the Rockies, who has not heeded its dual message: that a "hands-on approach" be adopted when harvesting and a "hands-off" approach when vinifying. I like the quote by Louis Caracciolo that I found on Almathea Cellar's website, which I believe sums it all up: "The winemaker is the custodian of the natural process who

must tease the complex subtleties from the wine naturally with a minimum of predetermined processing steps or cellar adjustments." The journey of New Jersey wine, like all epic journeys, is more than the activity it describes. It is about persistence, keeping a dream alive, daring to attempt difficult feats: in the case of winemaking, transforming rainwater and sunlight into an elixir.

# POSTFACE

With a blank notebook and good intentions, I set out to chart the remarkable journey of New Jersey wine history. Instead, I fell headfirst into a personal odyssey. It is not really proper to end a book with an apology, but I should get this off my chest. I tasted 1984 New Jersey wine, and it was a flat, not very good, peasant-style Chancellor. In 1986, after reading Howard G. Goldberg's praises of excellent cabernet from Atco, New Jersey, I set out to taste for myself. My intention was to mock, sneer and have a good laugh, even at Goldberg's expense. After all, I had been raised on the best wine in the world, even its *vin ordinaire* better than most wine in the world at the time. The fates were having none of it; the joke was on me as we headed to Margaux.

By October 2007, George Taber at Amalthea Cellars had again turned the tide of modern wine history, ushering New Jersey into the world-class wine arena. Five years later, on June 8, 2012, the story culminated at the Judgment of Princeton, the real final chapter of this remarkable journey. Starting in the 1600s, the whispers and prophecies of many New Jersey dreamers and visionaries were getting louder and truer as the twentieth century drew to a close, and no one was more shocked than myself. To find this shadow character entering the play in 1984 makes me want to laugh, not cry. Unlikely but true, New Jersey winemakers have planted their flag firmly in Mother Earth; there, New Jersey takes its place among the great wine regions of the world.

# Afterword

D r. Westrich has made a major contribution to wine history by succinctly summing up what has been happening in New Jersey in one sentence in this book, writing, "The last two decades have witnessed a veritable viticulture revolution in the Garden State."

My, oh my, how the world of wine has changed! Just over a half century ago, Alec Waugh, a well-respected British wine critic of the day, wrote in his 1959 book *In Praise of Wine*, "For the real magic and mystery of wine lies in this: that though wine be grown in innumerable areas, great wines can only be produced in special places and in minute quantities." By that, he really meant that great wines could only be made in France.

Today, world-class cabernet sauvignon is made in Stellenbosch, South Africa, and wonderful Ice Wine comes from Ontario, Canada. Pinot noir to die for can be found in Central Otago, New Zealand, and the world's best Malbec is made in Argentina. Those are only a few examples of the wine revolution. Why not in New Jersey?

Who would have thought back then, in 1959, that one day people would be seriously comparing wines from New Jersey with those of Bordeaux? Yet that happened in May 2012 at a tasting at Princeton University organized by the American Association of Wine Economists. French wines won first place in both the Chardonnay and the cabernet sauvignon categories, but New Jersey wines came in second in the white wine category and third in the red.

The myth that great wines could be made only in France was first shattered at the Paris Tasting of May 24, 1976, when two little-known

California wineries bested leading French châteaux in a blind tasting. I was lucky enough to have been the only journalist present for that historic event.

That inspired winemakers around the world to raise their aspirations and do better, much better. European wineries in countries such as Spain and Italy were no longer satisfied simply to make the same old plonk that their ancestors had produced for generations. They wanted to do better, and they have. In addition, winemakers as far away as Australia, South Africa, Argentina and dozens of other countries improved the quality of their products.

Science has also been mobilized to help winemakers. Research centers associated with universities have been helping vintners make the most out of what nature gave them. Winemakers are improving their products thanks to work being done from the University of Bordeaux in France to the University of California–Davis and from the Australian Wine Research Institute in Adelaide to the Rutgers Wine Grape Resource Center in New Jersey. New techniques such as drip irrigation and night harvesting have made it possible to get quality grapes out of hot areas where only inferior fruit grew. Scientists have also found new grape clones specifically tailored to local climates. Future benefits from such studies hold great promise.

The author points out that grapes have been grown in the state since early colonial days, but for most of that time they did not produce good wine. French-American hybrids or sweet blueberry wines dominated the market. In recent years, though, growing numbers of farmers have been adopting techniques developed in France, California or wherever they found world-style and world-quality wines.

Future generations will look back at the pioneers introduced in this book as the founding fathers of quality New Jersey wine. No one knows today how far science and their own hard work can take them. But they are part of the revolution in wine that started that day in Paris when I saw a group of French wine judges shatter the myth that great wines can only be produced in special places and in minute quantities.

*George M. Taber, the only journalist present at the Paris tasting, is the author of the book* Judgment of Paris—California vs. France and the Historic 1976 Paris Tasting That Revolutionized Wine.

# ADDENDUM

## New Jersey Wineries and Vineyards

Alba Vineyard—Finesville (Warren County)
Amalthea Cellars—Atco (Camden County)
Auburn Road Vineyards—Pilesgrove (Salem County)
Balic Winery—Mays Landing (Atlantic County)
Bellview Winery—Landisville (Atlantic County)
Beneduce Vineyards—Pittstown (Hunterdon County)
Brook Hollow Winery—Columbia (Warren County)
Cape May Winery & Vineyard—Cape May (Cape May County)
Cava Winery and Vineyard—Hamburg (Sussex County)
Cedarvale Vineyard—Logan (Gloucester County)
Chestnut Run Farm—Pilesgrove (Salem County)
Coda Rossa—Franklinville (Gloucester County)
Cream Ridge Winery—Cream Ridge (Monmouth County)
De Mastro Vineyards—Southampton (Burlington County)
DiBella Winery—Woolwich (Gloucester County)
DiMatteo Vineyards—Hammonton (Atlantic County)
4 JG's Orchards & Vineyards—Colts Neck (Monmouth County)
Four Sisters Winery—Belvidere (Warren County)
Hawk Haven Vineyards—Rio Grande (Cape May County)
Heritage Vineyards—Mullica Hill (Gloucester County)
Hopewell Valley Vineyards—Pennington (Mercer County)
Jessie Creek Winery—Cape May Court House (Cape May County)
Laurita Winery—New Egypt (Ocean County)

Monroeville Vineyard—Monroeville (Salem County)
Mount Salem Vineyards—Pittstown (Hunterdon County)
Natali Vineyards—Cape May Court House (Cape May County)
Old York Cellars—Ringoes (Hunterdon County)
Plagido's Winery—Hammonton (Atlantic County)
Renault Winery—Egg Harbor City (Atlantic County)
Sharrott Winery—Blue Anchor (Camden County)
Silver Decoy Winery—Robbinsville (Mercer County)
Southwind Vineyard—Millville (Cumberland County)
Swansea Vineyards—Shiloh (Cumberland County)
Sylvin Farms—Germania (Atlantic County)
Terhune Orchards & Winery—Princeton (Mercer County)
Tomasello Winery—Hammonton (Atlantic County)
Turdo Vineyards & Winery—North Cape May (Cape May County)
Unionville Vineyards—Ringoes (Hunterdon County)
Valenzano Winery—Shamong (Burlington County)
Ventimiglia Vineyard—Wantage (Sussex County)
Villa Milagro Vineyards—Finesville (Warren County)
Wagonhouse Winery—Swedesboro (Gloucester County)
Westfall Winery—Montague (Sussex County)
Willow Creek Winery—West Cape May (Cape May)

I am indebted to Professor R.P. McCormick for his illuminating account of the Royal Society's actions concerning winemaking in New Jersey.

Visit us at
www.historypress.net